Controlled Painting

Frank Covino

Controlled Painting

A sound approach to realistic
painting in oil and acrylics

NORTH LIGHT PUBLISHERS
WESTPORT, CONN.

Published by NORTH LIGHT PUBLISHERS, a division of FLETCHER ART SERVICES, INC., 37 Franklin Street, Westport, Conn. 06881.

Distributed to the trade by Van Nostrand Reinhold Company, 135 West 50th Street, New York, N.Y. 10020. Copyright© 1982 by Fletcher Art Services, Inc., all rights reserved.

Manufactured in U.S.A.
First Printing 1982

Library of Congress Cataloging in Publication Data

Covino, Frank.
 Controlled painting.

 1. Painting—Technique. I. Title.
ND1500.C68 751.45 81-22583
ISBN 0-89134-042-4 AACR2
ISBN 0-89134-044-0 (pbk.)

Edited by Fritz Henning
Designed by David Robbins
Composition by Banner Press
Color printed by Connecticut Printers
Printed and bound by Maple-Vail Book Manufacturing, Inc.

To Mark, my new son, and his
extraordinary mother, Patty, who
shares this creative accomplishment.

Contents

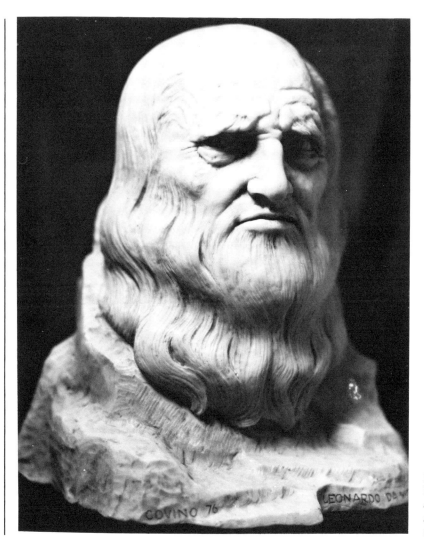

FIGURE 1
Leonardo da Vinci, *sculpted in Carazini by the author after a sketch made by the Renaissance Master. This bust is in the Burroughs Library permanent collection, Bridgeport, Connecticut.*

8

Introduction

This book is offered in response to the hundreds of inquiries I have received about the availability of my first analysis of the academic painting process, "The Fine Art of Portraiture" (New York, Van Nostrand Reinhold, 1970) which, I regret to say, is now out of print.

Over the years I have become increasingly aware of the specific needs of the amateur and professional painters who prefer to express themselves in a representational or realistic manner. It is hoped this book will satisfy some of these needs. The traditional manner of painting which I teach will be illustrated in part with photographs of some of my students at work at my Academy of Art in Fairfield, Connecticut.

I am convinced that painting in the classical academic manner is a craft with a scientific basis. It can be learned by anyone who has the desire, the patience, the discipline, and a reasonable amount of intellectual capacity. It is logical; it is straightforward.

Beyond craft there is art — the phenomenological gift that separates the imaginative of us

from the unimaginative, the composers from the players, the poets from the readers. It is the gift possessed by intuitive performers for the fascination of less conceptual, at times bewildered spectators; it could be said to be a spiritual gift because it has no lay ontology. We can ascribe to it no specific standards; we cannot say: "Art is..."and justifiably finish the statement, because the evaluation of art is like the identification of beauty: in the eyes of the beholder.

We cannot define art, any more than we can identify the source of the capacity to create it. Artistic expression of any real significance has transcendental linkage. No one can teach you to be an artist, but I can help you learn how to paint artistically. Furthermore, I can teach you how to incorporate elements in your painting that are present in works of great art. You can learn to become a good craftsman. You may already be an artist. If you are an artist with no knowledge of the craft for creative expression, you may indeed be frustrated.

If you become a good crafts-

man at painting, but lack the intuition and creative imagination peculiar to true artists, you will at least be blessed with the satisfaction of achievement and, perhaps, receive accolades from a less accomplished audience.

Painting is not a sport. It will not keep you in as good physical condition, but the product of your effort may be more significant, because your work could last long after you are gone. It is possible what you create could act as a kind of justification for your existence; a purpose, a reason for your life.

The problem with most painting classrooms is that the teachers frequently put the cart before the horse; students are encouraged to be creative before they have learned how to handle the tools of their profession. We don't find this peculiarity in any discipline other than the visual arts. Can you imagine a music teacher asking your child, who has never seen a piano, "Sit down and play something, Johnnie, and I'll tell you what you're doing wrong...," or a ballet teacher casting your daughter in a performance of *The Nutcracker Suite*

before she has even learned a *pas de deux?* One can't be expected to compose a symphony before learning to identify and reproduce notes and chords; nor can one create poetry before learning to speak and write.

The craft must precede the creativity if the expression is to be communicative. There are, of course, paintings that are said to be non-communicative. It is my belief that even these free expressions, if they are significant, are structured under the influence of time-tested principles of design and are expressed with some knowledge of the painter's craft. The only accidental stroke of a significant modern painter's work might be his first; from that point on he is designing, under the influence of his own understanding of good art.

The first elements of my craft were passed on to me by my grandfather and my dad. A formal art education at Pratt Institute broadened my exposure. In the process I earned my Master's degree in what is called the Science in Art Teacher Education. Attendance at two lectures by the analytic Frank Reilly at the Art Students League in New York City clarified many of the theoretical opinions I had confronted at Pratt from the writings of Albert Munsell and from my brilliant professor Maitland Graves. Some avant-garde professors at Pratt tried in vain to discourage my interest in the traditional or realistic approach to painting. Their criticism and compulsive drive for innovation and creativity only drove me deeper into the archives of the New York Public Library for clues from the Old Masters that might reveal their techniques. Research on Leonardo da Vinci extended my knowledge, and from it all emerged a direction for expressing myself with paint.

This book and the courses I teach are based on my findings. It is not my method any more than it is Frank Reilly's method. Rather, it is an accumulation of knowledge of the past based on the approach of the great innovator Leonardo da Vinci. But even da Vinci was a student in his youth. He too had to learn his notes and chords.

It is certainly possible the system of using a pre-mixed color palette with matching gray values preceded Leonardo, but my research uncovered no evidence prior to the scrawl of a da Vinci student, Giovanni Boltraffio, in his notebook describing the Master as "..... mixing ten vessels of dark to light gray tones to treat the color pigments." Reference to Boltraffio's comment is made by Merejcovsky in his book "The Romance of Leonardo da Vinci." This concept of conditioning specific color values with the addition of corresponding neutral gray values was an innovative solution to the problem of changing color intensity. The procedure was practiced by many realistic painters following da Vinci through the 19th century. It was only rejected in the era of Impressionism, by creators of the various aberrations in the develop-

FIGURE 2
Students at work in my academy in Fairfield.

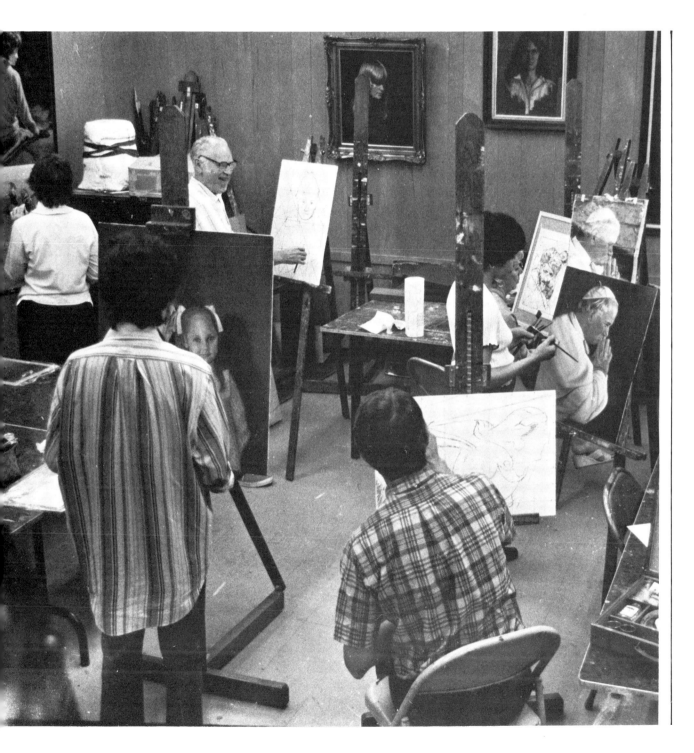

FIGURE 3
Laocoon and His Sons

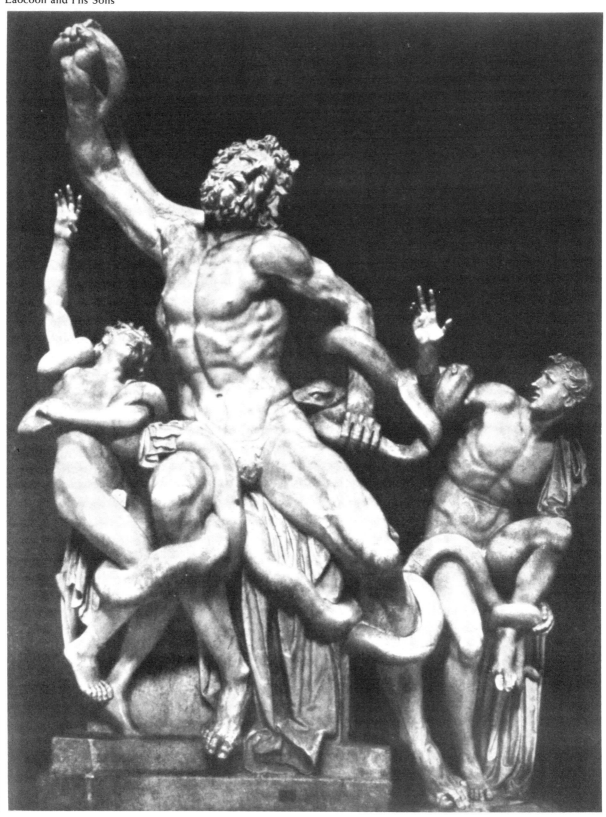

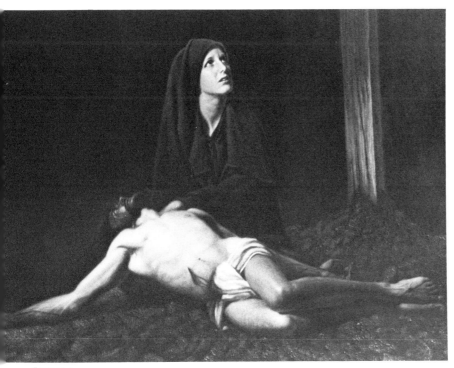

FIGURE 4
Pieta di Covino

ment of the "Modern" period of painting.

The system was brilliantly documented in the writings of Albert Munsell. In this century it was practiced mainly by painters whom the critics like to pejoratively label "illustrators."

The critics' assumption is that art can have little value if the form is reminiscent of a previous era.

Included here as it was in my first book is a photo of "The Laocoon," a heroic statue in marble. This is a magnificent work of art, but what is really significant is that the stone, as skillfully carved as any Michelangelos, was dug out of the earth during an excavation when Michelangelo was a child. If he had looked at this piece, created by some unknown Greek 2,000 years before his birth, and said, "Fantastic! But I can't work in this ancient realistic manner if my own work is to have value...," think of what the world would have missed. No David. No Pieta. No Moses. No Slaves. How much poorer we would be!

For years I have wanted to paint a Pieta, partly for the challenge of creating a familiar theme executed in a traditional manner; partly because I think that Mary, the woman and mother, has been slighted by historians. It is interesting to note only one of the four gospels (John) in the New Testament even mentioned Mary being at the cross when the crucifixion took place. Little is known of what she looked like. Surely the saccharin conceptions of her looking like an Irish Catholic are inaccurate. My portrait of Mary looks Semitic and her eyes are brown, probably a more accurate representation of a Jew of that time.

My Pieta may not stand as a great work of art. However, I know it has affected some people in a manner most rewarding to me. Once, when I went to view the painting which was then hanging at the Calvary Episcopal Church in Bridgeport, Connecticut, I saw kneeling before my picture a family of five local residents in deep prayer and meditation. Such moments and others like it give me the strength to defend my manner of painting as significant and worthy of perpetuation.

Historical paintings have been a major focus of painters since man first expressed himself with marks on a two-dimensional surface; cave paintings attest to that. The realistic painter is in fact a historian. If he chooses to paint portraits, he is a recorder, a documentor of a particular person at a particular moment. Even landscapes are historical, and many successful allegories have been expressed with still life arrangements. *Communicative* art is art that tells a story — art that speaks to anyone who can see.

Art bridges all spoken language; it is a higher form of communication. Understanding is universal.

Years ago I was sent from Korean combat to Japan for two weeks' "rest and recuperation." I wanted to try skiing over the beautiful mountains near Lake Chuzenji. My command of Japanese was limited to "hello" and "thank you," but my trustworthy sketch pad worked to communicate to almost anyone so I could make the trip from the airport at Tachikawa through Toyko and ninety miles inland via train to the snowfields at Nikko!

Communicative art is doubly rewarding. First you can satisfy yourself by expressing your thoughts allegorically, but the major satisfaction comes when the response of your audience is the reaction you intended to elicit. Even a reaction totally different from the one you intended to motivate can be satisfying.

It pleases me to be able to *move* people; to cause a reaction. (Perhaps not always a pleasant one, I should add.)

What I strive for is an honest, sincere personal statement in the realistic tradition. No gimmicks. No fad distortions. No psychedelic colors or 'pop' symbols on the order of Campbell's Soup cans. I want my brush to speak. If but one spectator hears my message my effort will not have been in vain.

From a technical point of view, my "Return of the Lamb" was not an easy assignment. None of the models I considered could project the expression that I had in mind, and most of their figures left something to be desired. I decided to try to create the action myself. By grabbing onto two overhead beams and lowering my head but not my eyes, I was able to simulate the pose and expression that I had in mind. My wife clicked off some photos and the reference material was complete, right down to the rag wrapped around my hips.

The underpainting was done in acrylics; the oils were superimposed. My palette was pre-mixed and in total *control*. By mixing each flesh value half the size of my fist and covering each with a separate piece of Saran wrap, then covering the entire palette with another piece, I was able to keep the paint alive for the three months needed for completion. A few drops of medium were added to each pile every week. This procedure will be described in a later chapter, along with my recipe for an ideal medium.

Many art students avoid classrooms that teach in the Academic manner because their recalcitrant personalities cannot accept structure and discipline. They are afraid of inhibiting their "free" expression. Others simply don't have the patience for learning the craft. Then there are the "purists" who believe that anyone who uses photographic reference cannot be an artist.

The use of photography is a logical extension of the Academic curriculum of the High Renaissance schools of painting. To avoid its benefits is to be naive. Certainly the Academic method is not the only way to paint. I won't even say it is the best way; it is the way many Masters between the sixteenth and nineteenth centuries painted. Master technicians of our own time, such as Salvador Dali, also follow the Academic approach. It is the way I prefer to paint, and it is the manner of painting that I teach. The surprising thing is that every week while dozens of my students are working on individual projects in the Academic tradition, no two of their paintings look alike. Everyone brings something individual to his art; some indefinable characteristic as unique as our personal signatures.

A contemporary group of classical academicians with a healthy respect for the past has continued to create recognizable forms on their canvases, sensitively record-

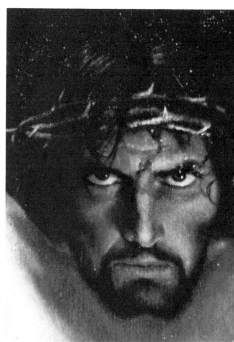

FIGURE 5

Return of the Lamb as a Lion (*detail*)

FIGURE 6
Return of the Lamb as a Lion. *The author is shown completing his controversial statement of the last judgement.*

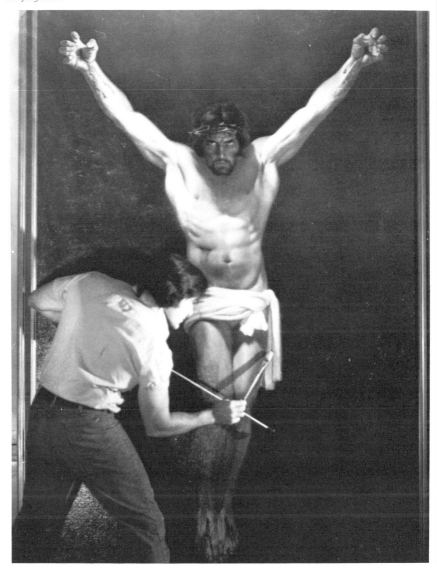

ing the life of their time. Men like Norman Rockwell have been ridiculed for their down-home sentimentality, while little has been said about his expert painting ability. Andrew Wyeth stands alone, it would seem, as a champion of academic realism. He is one of the few who commands a one-man show in one of the posh New York galleries, but even his reviews generally extol his capacity as an abstract designer and deride his tendency toward illustration. Few critics would appreciate the realistic aspects of a contemporary genre painting in a public review for fear of being labeled reactionary. And few books authoritatively describe the actual process of painting academically. Too often the offerings on the art store bookshelves are of the artist's accomplishments, with little explanation of his methods. How often have you wondered, "How did he do that? It looks so . . . real!" This book will provide some answers.

A favorite argument against realistic representation is that it is futile and foolish to attempt to compete with a camera. The argument is shallow. The camera is a recording instrument that is only one of the artist's tools. The camera can only record what it sees. The artist can modify the camera's recording to accommodate basic design principles that will elicit a response from his audience because of the new relationship he has created.

The natural bent of the human brain is to appreciate equilibrium and order. Nature, the ultimate artist, designs with tremendous scope, but the lens of a camera takes a small piece of the *whole* concept and isolates it. The artist can take that isolated part of a whole and redesign it, so that its constituent parts relate to each other and create a unified complex within the boundaries of his canvas. The artist imitates nature, but he need not recreate her forms with verisimilitude. What is meaningful is the artist's capacity to select, modify and delete from his immediate perception, and in so doing imitate the *process* of nature in her complex design of the universe.

The camera is frequently inaccurate, portraying what it sees through a single lens that distorts in accordance with its proximity to the subject. This is apparent in the photographs that illustrate the painting of the nude in Chapter IV. Look how distorted the legs appear in illustrations and because of their closeness to the camera lens. The completed painting shows a remarkable difference.

We normally see stereoscopically; our right eye does not see the same image recorded by our left eye at the same time. To prove this, hold a pencil in front of your face and close your left eye. Notice what forms in your right eye's field of vision the pencil divides and make a mental note of *where* it divides those objects. Now, without moving yourself or the pencil, close your right eye and look with your left eye at where the pencil divides those very same forms. The divergence is startling, isn't it? Your right eye does not see what your left eye sees! Such a stereoscopic illusion cannot be created with the average camera, as it records through a single lens. For this reason, round forms appear to have sharp edges in photographs; smart photographers use a wide aperture on their lens to at least throw out of focus distant objects, but even with the use of this device, unless it fills the viewing area, the edges of a ball will appear the same as the edges of a coin. The wise artist is not fooled by this deception. He will soften the side edges of all round forms to render them more truthfully than the camera, in relation to our natural stereoscopic perception.

Would it surprise you to learn Leonardo da Vinci may have used a type of photographic image in formulating some of his painting? The principle of the *camera obscura* (in Latin it means dark room) was first noted by Aristotle around 300 B.C., but it was Leonardo who connected the principle to the way our eyes function. Could his discovery have been an accidental ob-

FIGURE 7
The edges of a coin are sharp in actuality.

FIGURE 8
There are no edges on the ball, yet the camera reproduces them as sharp as a coin!

servation when the intense Mediterranean sun broke through a crack in one of the walls of his garret, creating a kind of pinhole camera? Is is not surprisingly coincidental that Leonardo's paintings were among the earliest to suggest landscapes in correct perspective? Possibly, for it was in 1558, about 40 years after da Vinci's death, that Giambattista della Porta, a physi-cian in Naples, published the first accounts of drawings based on the camera obscura.

For centuries we have marvelled at the paintings of Leonardo. Have we ever accused him of using "photographic reference"? No. Neither did the hundreds of famous artists who followed in later centuries, many of whom must have been exposed to primi-tive "cameras" of one sort or another. Why then, four centuries later, should so many critics put down paintings that are influenced by photographic reference? *If the painter is responsible for the initial photograph it is part of his original creative process and the camera should be recognized as one of the tools of his craft.* Some students create paintings from other photo-

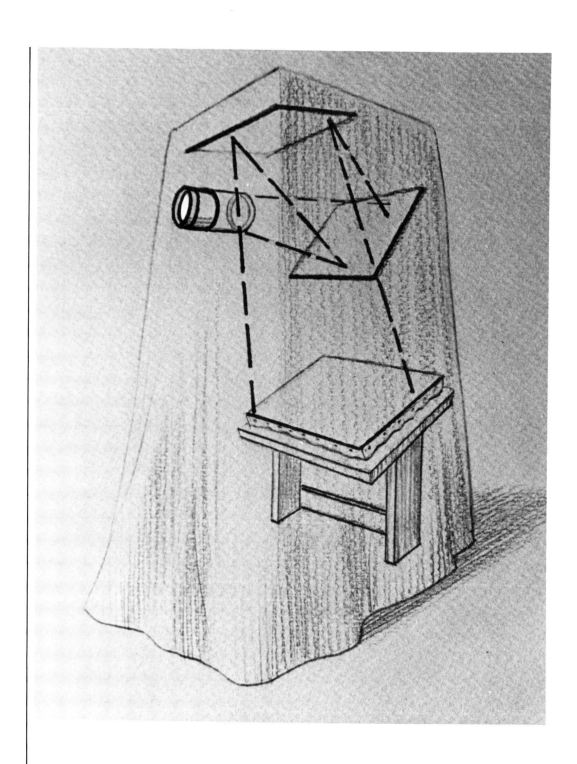

FIGURE 9
*Early camera obscura was a dark chamber with an
enlarging lens affixed to one wall plus two mirrors
which bounced the image to the canvas.*

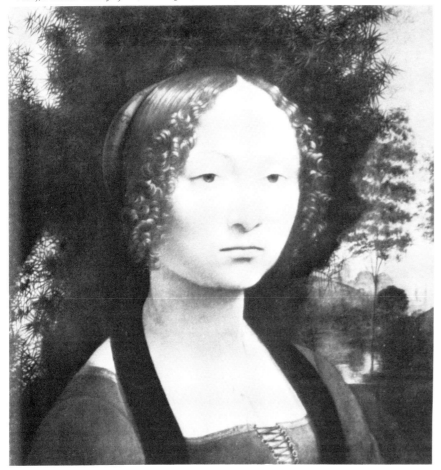

grapher's photos. Such practice seems to me unethical and may be considered plagerism.

I encourage you to work from your own photographs. Although the camera is a mechanical instrument, it is totally dependent upon a human mind which has the power of selection, modification and operation. That mind is the original artist; it conceives the idea, poses it, selects a speed and aperture number for a particular lighting circumstance and depth of field, and directs the finger to push the button. If that mind belongs to the painter who uses the photo for reference, the camera becomes a vital part in his creative process. The defense rests.

This book is intended to satisfy the needs of professional artists, semi-professional or "Sunday painters," art students or the esoteric group of inquisitive intellectuals who are not content with their perfunctory emotional responses to representational paintings, but who wish to analyze the structure of the stimuli and have a more thorough understanding of *how* the art was created. Not everyone has the desire for such knowledge. For those who already practice the craft of painting the need is obvious, but what of the millions of individuals who have had no art training but are exposed to art constantly in their daily lives? Is it necessay to know how a painting was created in order to appreciate it? Is it necessary to know how a symphony was composed in order to experience the pleasure of listening to it? For many, perhaps for the majority, this need is not apparent. Most people are content to respond emotionally to any form of sensuous stimuli without analyzing its cause and effect. Curiously, they might be the happier lot, for the thirst for total knowledge does seem to be an unattainable goal; complete knowledge of any craft is as elusive as Plato's Perfect Form, but, as with his quest, the *process of the search* is the essence of the creative achievement.

Because I have intimated in my previous books that the craft of painting is an intellectual procedure that utilizes various forms of *measure*, many students have asked me the question, "Do you really think that *anyone* can paint?" My answer was once the basic premise of the British Royal Academy, as quoted by its first president, Sir Joshua Reynolds, ". . . the superiority attainable in any pursuit whatever does not originate in an innate propensity of the mind for that pursuit in particular, but depends on the general strength of the intellect, and on the intense and constant application of that strength to a specific purpose."

The renowned English educator and foremost painter of his era cannot lay claim to the originality of that concept. Benedetto Croce[1]

[1] *Aesthetic,* Noonday Press, New York, 1956)

FIGURE 11
Sir Joshua Reynolds, **Lady Elizabeth Delme**
and Her Children, *National Gallery of Art,*
Washington, D.C.

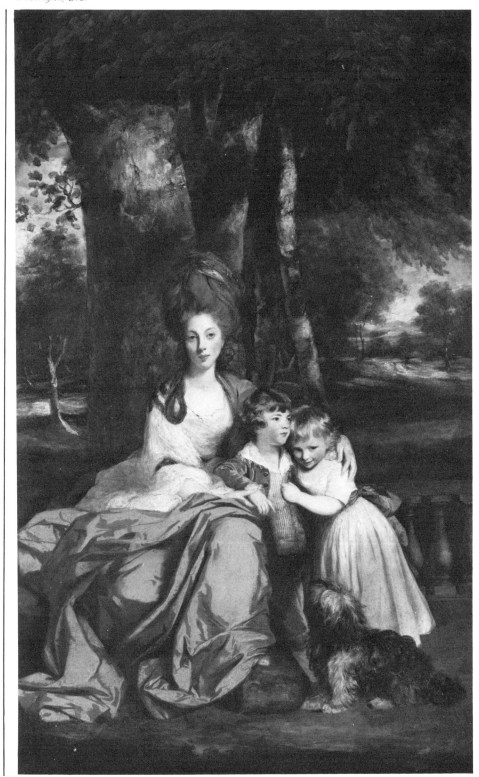

suggested that there are no born cooks and no born poets, and Leonardo da Vinci was living proof of the capabilities of the human mind when its "general strength of the intellect" is applied constantly to various creative endeavors. Too many of us in this century are guilty of wasting our minds, either in pursuit of one goal for its promise of social security or as spectators and appreciators, content to admire the efforts of others and satisfy our basic hedonistic needs vicariously, without giving of ourselves in return. Victims of our immediate environments, we are brainwashed into believing that artists are "gifted" freaks of nature, and without "talent" our efforts to create such as they do are futile. It is no wonder that many professional artists walk around on Cloud Nine believing the hogwash we have imposed upon them with our adulation of their "gift" for creation of beautiful things. Few will admit to the science behind their craft; to do so would be to deny their *genius*. Broken apart, that genius is no more than a unified complex of human traits that all of us have in one percentage or another. Unfortunately, most of us stifle our own capacities by spending all our hours appreciating the work of others. The ability to create in one craft is an intellectual capacity that can be directed toward significant creative achievement in any other. I don't know the first thing about "creating" a cake, but I suspect I could do as well as Sara Lee, if she showed me how.

Academic painting, in the realistic tradition, is no more than a disciplined intellectual approach to painting what you see, with modifi-cations and deletions that accommodate traditionally accepted principles of good design. The first task, then, is to learn how to see. To see is to understand. I know a few blind people who can *see* better than some students, who are content to merely *look* and not analyze for a more thorough perception. My daughter Cameron could quite accurately identify *light* and *dark* when she was only two years old. It will be a while yet before she is able to determine precisely *how* dark or *how* light things are. Most of us never go beyond black, white and perhaps gray in our adult analyses.

If white is total light; one hundred (tenth value) percent light, and black is the absence of light; zero, you don't have to be of extraordinary intelligence to imagine 99 percentages of light in between. As I look at the couch before the frame window in my living room I can safely estimate at least four different percentages of light on its cover as the light of the sun spills into the room, i.e., the illuminated top plane of the couch is about eighty percent light except for some folds which are about seventy percent light; the shadowed side is about forty percent light, except for the spots that catch reflected light from the floor, which measure about fifty percent light. If you can understand that basic academic description, you have the "talent" required to be able to see. The mechanics for portraying that perception are just as academic. This book will show you several techniques.

To become a good academic realist there is another prerequisite. You must *want* to paint in

21

a representational manner. Students who do can't imagine why anyone would not want to, while students of abstract expressionism can't understand why anyone would want to do what a camera is quite capable of recording. Beauty is indeed in the eyes of the beholder and arguments in defense of either practice are counterproductive.

This book is no more than a primer for the craft of painting in an academic realistic manner, punctuated with several of my own interpretations of the phenomenon of perception, visual stimuli and response. Because there can be no ontological definition for "art," any book you read about it has to be personal conjecture of the author. My opinions are based upon many years of experience as a painter (of portraits, primarily) and as a teacher of hundreds of adults who for one reason or another never had the opportunity to learn about the craft of painting when they were younger. Doctors, dentists, mechanics and housewives have astounded themselves and others with the art they have produced in my classroom. It doesn't matter whether their paintings will one day hang in the Louvre. What does matter is that they have discovered a new avenue for creative expression totally unrelated to their particular area of concentration in their normal lives. Because art is not functional, other than being possessed of visual stimuli, it has a curious satisfaction connected with its creation. D.H. Lawrence hit upon it when he wrote ". . . kindling the life quality where it was not. . ." Artists are truly ". . . transmitters of life."

To create something that would not exist were it not for your inspiration is one of the great joys of life, but like so many other of the natural pleasures, is seldom exercised. So it must be with music, not the mere playing of an instrument, for that has only temporal significance, as the creation is terminal. To compose, on the other hand, is more akin to creating a painting, as the work continues to exist even after the passing of its creator.

If you are already a painter, it is my hope that what follows will increase your vocabulary of art processes and inspire you to continue creating. If you have no time to practice the craft but enjoy painting from the standpoint of a spectator, my aim is to enlarge your capacity to appreciate by revealing the thoughts and methods of the artist, thereby bringing you closer to an understanding of his intent and your anticipated emotional response.

I|The Camera as a Painter's Tool

If it seems odd to begin a book on classical academic painting with a chapter on photography, it is because you are not aware of the significance of photographs as tools for accomplishment in our field. Since its development in the middle of the last century, the camera and its attendant photographer have tried to reproduce the visual impact of a good realistic painting. Masters in the photography field have come close, because they have borrowed from the classical academic painter and have implemented, with their camera, tested design principles and emotionally motivating factors that are apparent in great paintings. Among these are the precepts of unity through dominance, repetition with variation, balance, (we'll discuss these soon), plus various compositional and psychological ploys designed to elicit specific audience response. On the other hand, many good paintings have been created with photographic reference in order to freeze a particular characteristic of a form that is subject to change, i.e., the expression on a portrait subject; the lighting of a landscape etc.

Both pursuits deal with visual stimuli. Painters and photographers compose in a similar manner. Both present a luxury product, i.e., aesthetically pleasing but not utilitarian. The biggest difference between the two crafts is the fact that the final product of one is produced by a machine, while a painting is of human contrivance and modeling. Granted, in most cases there is a human mind behind the operation of a camera, but its options for a totally creative act are limited, i.e., the camera cannot move a tree, subdue a sunset, delete an unattractive blemish on the model, create tactile variation on the surface of the photograph, etc. Some of these things may be accomplished by a skilled darkroom technician, but they are in the nature of tricks rather than an artist's spontaneous response in the act of creating. In addition, it is impossible to produce a color photograph that will last as long as a painting.

The wall of professional jealousy that appears to have developed between the crafts is an unfortunate one. A photographer who captures a scene at dusk, diffusing distant edges of the forms in his composition by opening his lens wide, is lauded as a master who has created a photo of "Impressionistic" quality. The portrait photographer is applauded for his "Rembrandtesque" lighting which dramatizes some celebrity. The architectural photographer borrows from Mondrian to compose his structure and is given an award for brilliant design. When can you remember a painter gaining acclaim for his ability to paint like a camera? He is more likely to be deprecated by the intellectual establishment. Some art show organizers will not even consider accepting a painting if it appears to have had photographic reference.

Illustrators have less anxiety about using photographs as reference for their paintings. There is a ridiculous mystique attached to the painting created entirely from imagination, and an equally painful prejudice against paintings which are not.

Recently I served as one of three judges for an art exhibition.

One of the judges, a curator of a well-known museum, dismissed most of the portrait entries as unworthy of anything but a low grade, simply because they looked like "they were done from photographs." The fact that she did not evaluate each work for its individual merits as a work of art immediately disqualified her, in my opinion, to render a fair judgement.

Renaissance painters studied as apprentices in the bottega or workshop of a reputable Master. There they began by sweeping the floor, making gesso, cooking oils, grinding pigment and cleaning brushes. Between chores, they watched, auditing the work of student artists who had senority and listening attentively to the direction of the Master. Sketching was first in their educational process and some apprentices struggled for years to train their perceptual acuity. A graphing device, similar to the one I prescribed in the next chapter, trained the student's eye to see with accuracy and that capacity was eventually transferred to free-hand sketching. Casts were used for the first models, illuminated by a principle light source to create a strong dark and light pattern.

Additional years were spent painting models in bistre or verdaccio, two methods of underpainting monochromatically. Various forms of measure and devices for accurate portrayal were considered tools of the craft, not the least of which was the *camera obscura*, a projection device which capitalized upon the fact that a brilliantly illuminated scene will be projected smaller and upside down through a small aperture onto the opposite wall of a darkened chamber. A lens affixed to the aperture enlarged the image, while a mirror inverted it. Leonardo speaks of younger painters reproducing landscapes on glass attached to their easel, then taking the glass tracing back to the studio for transference onto a panel. Research into the various methods and measuring devices that were employed by Renaissance painters and by virtually all who followed, in an effort to portray the world around them realistically, leads one to view deprecations of the camera as a painter's tool as a naive notion.

Of course, the Old Masters would have used the camera as a tool for their creative efforts if they had had it. Undoubtedly, they would have welcomed it. Their learning procedures probably would not have changed much. Sketching would still have been the first creative experience, and the underpainting methods mentioned would follow. All that may have changed is the type of model for the initial training experience. Why hire a model to pose for hours in clothes which change their fold patterns every sitting (to say nothing of her expression), when those folds and an ideal expression could be frozen for hours of study in a photograph?

Many art students are not mechanically adroit and are intimidated by all the numbers and dials on a good camera. The fact is, those numbers and dials of the camera are simply elements of measure that are quite simple to master. Moreover, once learned, the same dials can be manipulated to produce a different impression from the one before the camera.

The camera can be a good deal more than an instrument which records that which is before it, and the photograph can be carried further by using it as reference for a significant painting — with one provision. For the act to be truly an original and creative one, the same artist should be behind the camera and the painting. Sharing the creative act by using photographs taken by another may lessen the significance of your work. Also, by only using your own photos, you avoid any chance of being accused of plagerism — taking the work of another as your own. Students in my classes begin their learning process by using other photographer's photographs as reference for their first paintings. This is a practical method of learning to paint when the room is small and each student works on an individual project. Later, they are encouraged to master the camera and create their own reference.

There is insufficient space for me to present an entire manual for the operation and creative use of a camera. The equipment that is available alone would take up more than half of this book. What follows is a brief explanation of the photographic process plus my opinion of what equipment would be most useful to the classical academician; how to use it and how to manipulate it to create reference for your paintings that go beyond the typical picture postcard.

The camera functions much like the camera obscura of the ancients, except that it records on film the illuminated scene that is projected through the aperture. On black and white film the dark and light *values* of the projected scene are burned into the light-sensitive film emulsion in degrees of intensity, i.e., very brilliant light would make a strong impression in the emulsion of the film, while an object or area which reflects little light would create a minimal impression.

When the film is processed by immersion into a developing chemical, into an acid which stops that development, and into a chemical bath which gives the image longevity, the final result is what we know as a *negative*. The processing washes away the emulsion of the film except for where it has been burned by the light rays. This, too, is relative to the intensity of the light that has struck the film. Bright light preserves most of the emulsion and the processed film shows it as black; while no light striking the film would result, after processing, in clear film, as the entire emulsion of that area would be washed away.

The negative image is a reverse recording of the dark and light values of the scene (the term *value* in art refers to a gradation of dark and light tones). Later we'll discuss the importance of specific value analysis to the classical academician. For now, imagine black to be zero, the absence of light and white to be a tenth value, one hundred percent light. Then imagine nine equidistant steps of gray in between, each representing a percentage of light and assigned a number from one through nine to define its precise gradation. Negative film records values in reverse; light objects appear dark and vice versa.

By projecting light through negative film and allowing the pro-

jection to strike a *developing out* paper which has been coated with a *silver chloride* emulsion (for contact prints) or *silver bromide* (for enlargements), a positive print can be created from the negative. The silver chloride paper is usually used by photographers for examining their photos all together on one contact sheet. (Contact means a print that is the same size as the negative.) Silver bromide coated papers provide a greater range of gray values than papers coated with silver chloride, which are more contrasty. A better paper available combines the two chemical emulsions; it is called *chlorobromide.* For our purposes, *resin coated* papers are best for black and white prints, as they dry rapidly and need less chemicals and washing time.

For enlargement, the light that is projected through the negative is transmitted through an enlarging lens in a darkroom. So you can see what you're doing while working in a darkroom, a low wattage colored lamp called a *safelight* is permitted. The developing paper is insensitive to that particular color light. Conventional papers require the yellow-green OA type safelight, except for *polycontrast* paper which requires an amber colored safelight. The safelight allows you to expose your developing paper to the light that is transmitted through your negative via the lens on your enlarger, and to follow with immersion in the necessary chemicals for development and painting. Any other kind of light during this development would expose and darken the print paper.

For development of the print, it is submerged into a tray of

FIGURE 12
Negative

developer for a couple of minutes; next, it is emersed into a stopbath solution; then into a tray of *hypo* which fixes the print, or makes it more permanent. A *water* bath washes off the hypo, and a tray of *photo-flo* solution to prevent curling usually completes the development. There are a great number of books available to guide you. I recommend Aaron Sussman's eighth revised edition of *The Amateur Photographer's Handbook* (New York,

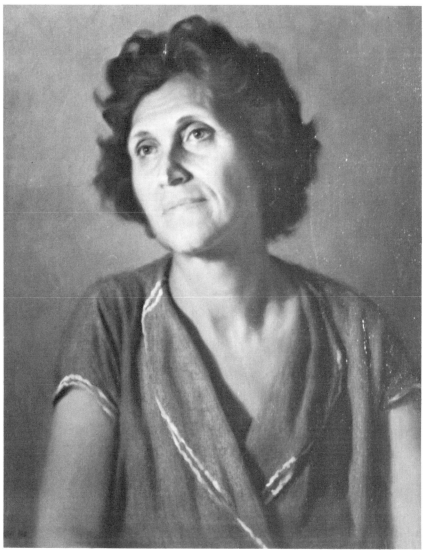

FIGURE 13

Photograph of my portrait of my Aunt Concetta.

Crowell Co., 1973) as a most complete tome on the use of the camera and on the processing of film and paper.

Is it necessary for the painter to get involved in darkroom processing? Can we just leave development and printing to commercial studios and concern ourselves with picture taking? My answer would be dependent upon the time you can give to your creative work. For many, painting is a spare-time activity, and leisure time is limited. For a while, at least, you may forget about photo processing and concern yourself more with pictorial composition and design. Later on, if time permits, it would be helpful to set up a basic darkroom. The creative advantages are especially valuable to the artist, and it is more economical.

There are things you can do in the darkroom to improve the picture you have taken. Often, selective *cropping* or trimming of one or more sides of your print would result in a better composition than that of your original photo. This is easily accomplished during the procedure of projecting light through your negative via the enlarger. You can also darken some areas of the print, simply by giving those areas more light exposure. This is done by shielding the rest of the projection with your hand or with a cut out piece of cardboard. The procedure is called *dodging.* Small areas of the projection can be dodged to allow the rest of the projection to receive more light and thus darken. For this adjustment, a kneaded eraser on the end of a long wire works well, as the eraser can be shaped into various forms. For photographers, the darkroom is their last opportunity for completion of the creative act.

Since we are using photographs primarily for reference, darkroom adjustment of the original negative is not critical. Certainly it is possible for the painter to benefit from photography without ever getting into the act of processing. If you feel the scene in your print would look better darker, you would simply

27

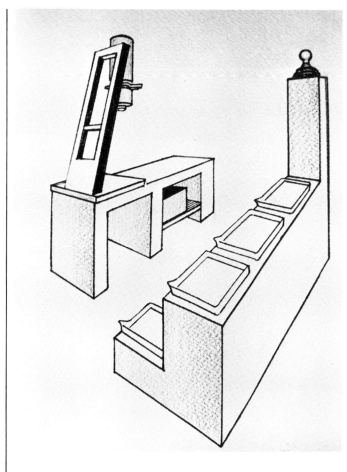

FIGURE 14
You can set up a darkroom in less space than you may have imagined. This is the author's arrangement at his Vermont studio.

FIGURE 15
The area that is dodged will receive less light from the enlarger and thus print lighter in value.

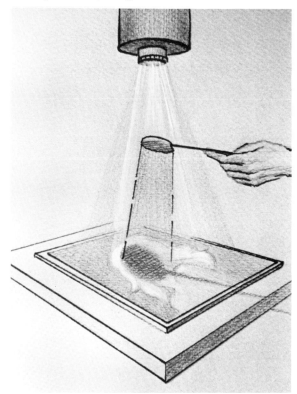

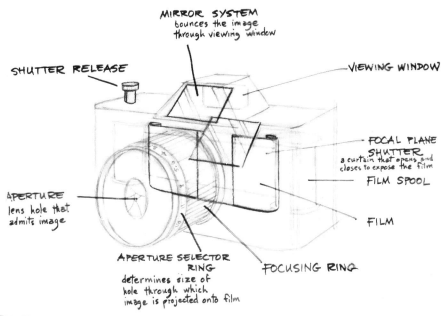

MIRROR SYSTEM
bounces the image
through viewing window

SHUTTER RELEASE

VIEWING WINDOW

FOCAL PLANE
SHUTTER
a curtain that opens and
closes to expose the film

FILM SPOOL

APERTURE
lens hole that
admits image

FILM

APERTURE SELECTOR
RING
determines size of
hole through which
image is projected onto film

FOCUSING RING

FIGURE 16
Schematic diagram of a single lens reflex camera

paint in the adjustment on your canvas or panel. The values of the scene or model viewed by the camera can be adjusted by manipulation of the dials on the lens, or with the use of color filters. Let's take a close look at the instrument.

Our example will be single lens reflex (SLR) models only, because they are most practical for the painter's purpose. For one thing, you view the scene through the lens, the same lens that records the scene. More important is that the enclosed light meter of a SLR reads the subject through the lens. If a color filter is screwed onto the lens you'll still get an accurate reading. On a single lens reflex camera, a mirror is angled behind the lens. The mirror image is bounced above onto other angled mirrors, which in turn reflect the scene through the viewing window of the camera. When the settings

have been made, and the camera is activated by squeezing down the plunger, the mirror behind the lens is mechanically lifted to allow the scene to be recorded on the film.

That plunger or small button that you press down to activate your camera opens a cloth or metal curtain that is near the front of the film. This is called a *focal-plane shutter*. The amount of time that the curtain remains open is the *speed* that you select for the photograph. Note the shutter speed control dial. Imagine each number to be the denominator of a fraction of a second, i.e., 500 = 1/500th of a second; 250 = 1/250th of a second; 15 = 1/15th of a second, etc.

The speed you select may be determined upon the action of the scene, i.e., to stop the movement of a waterfall, 1/250th of a second or faster would be required. It may also be selected to guard against camera movement by an unsteady hand (high speed), or it might be prescribed by your choice to allow more light to reach the film (low speed) in a dimly lit situation. Fast speed allows less light to reach the film (shorter exposure time).

The numbers on the ring of the lens are designated *aperture* readings. These figures regulate the size of the hole or diaphragm of the lens through which the light reflected from the scene is transmitted to the film. The numbers are called "*f*-stops"; the *f* stands for *factor* or fraction and it refers to the size of the aperture in relation to the focal length of the lens. Thus, *f*/11 means that the size of the hole is 1/11th of the length of the lens. The higher the *f* number or stop, the smaller the aperture, or hole. This makes for sharper back-

29

FIGURE 17
Cropping and enlarging can turn a commonplace snapshot into an artistic photo. Student Carol Houston snapped photo A. The author suggested cropping to produce better designed photo B.

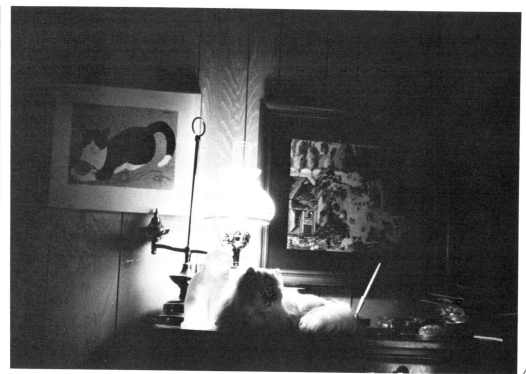

A

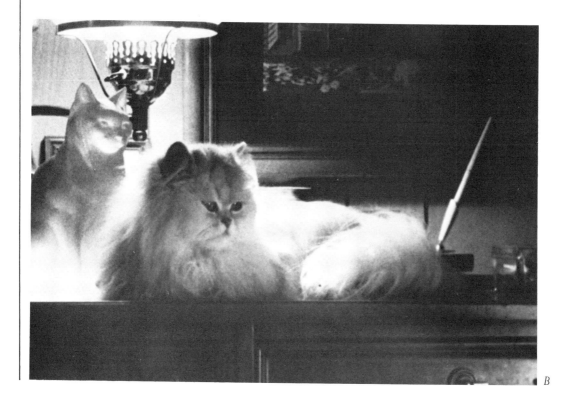

B

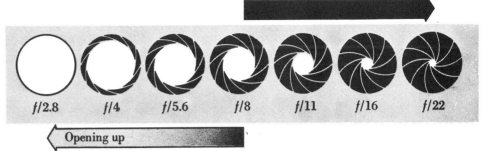

FIGURE 19
Controlling exposure by stopping down.

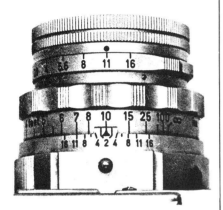

FIGURE 18
The elements of the lens in a 35 millimeter camera.

ground detail. A larger opening lets in more light and diffuses detail in all areas except for the immediate point on which the photographer has focused.

So, there are two means by which you may control the amount of light that reaches the film: the speed of the shutter, and the *f*-stop. Modern single lens reflex cameras make it easy for you to determine which speed and which *f*-stop; as they have a built in light meter. Some cameras allow you to pick the speed and the meter advises the *f*-stop, usually seen in the viewing window. Some cameras allow you to pre-select the *f*-stop and the meter advises the speed. Better cameras provide both speed preferred or aperture preferred guidance. When you purchase a camera, make it a single lens reflex camera that includes a light meter. If you already have a camera that does not include a light meter, you'll need to purchase a separate meter for accurate light measurement.

There are two types of light meters, *reflected* and *incident*. Meters built into cameras are of the reflected type; they measure the

amount of light reflecting off objects. Separate reflected light meters can get very sophisticated, measuring light reflected from an area as small as one degree (a *normal*

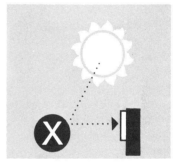

FIGURE 20A
A reflected-light meter measures light reflected from the subject. "x" = subject

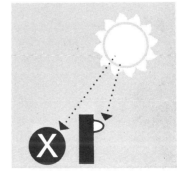

FIGURE 20B
An incident-light meter measures light falling on the subject.

31

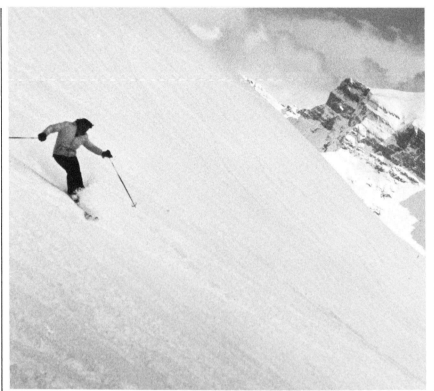

FIGURE 21

FIGURE 21
For correct value recordings of winter scenes, you must point your metered camera at a known fifth value, like this massive shadow behind the author at a Lake Louise ski area in Western Canada.

FIGURE 22, 23
Reflected light meters, like those included in cameras record black objects and white objects as a fifth value. Garment on the left is black; the right is white!

FIGURE 24,25
Same two subjects placed correctly in value, by stopping down three stops for the black garment and stopping up three stops for the white. Stopping down (faster speed or higher number f-stop) lets less light through the lens.

FIGURE 22

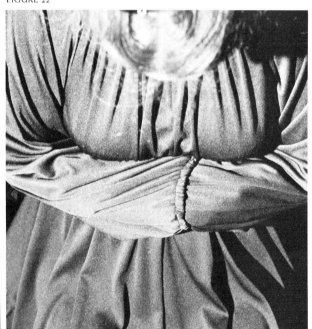

FIGURE 23

50mm lens on a 35mm camera encompasses about 45 degrees). With such a light meter, you could measure the light reflected from a face thirty yards away! Some cameras have equally sophisticated *spot* light meters, a decidedly coveted feature. All reflected light meters advise speed and aperture readings for a rendering of the reflecting area to be reproduced at about a fifth value (on a ten point scale between black, or zero, and white, or ten). This is a critical consideration. Snow scenes, for example, can only be accurately measured if the reflected light meter is pointed at snow that is in shadow (when it is a fifth value).

If you were to photograph brilliant white snow, and it filled the viewing window of your metered camera, the meter would give you advice for recording that white snow as a fifth value gray. It would, in fact, advise you a speed and aperture selection for a fifth value gray, even if you filled your viewing window with a *black* object. For this reason, the meter reading cannot always be trusted. It can only be relied on if it is pointed at an object that is known to be a fifth value, or if all the values of the recorded scene *average* to a middle value gray. The meter reading must be adjusted in very dark or very light situations, allowing less light to reach the film when the composition is predominantly dark, and more light to enter when the scene is predominantly light.

As an example, let's suppose that you wanted to pose a subject with Rembrandt-type lighting (dark background and shadows, small area of light on the forehead diminishing as it spills down the face). You set up your model and floodlight, focus your camera, read the advised meter calibration. Do you follow its advice? If you do, you'll end up with the dark areas appearing as a middle value gray and the light areas completely washed out, lacking tonal detail. Instead, observe the meter advice and stop down (let in less light than it advises) by two stops. The result will be blacker darks and more detail in the light areas.

There is a method used by photographers called the *Zone System*, which begins with the procedure I have just explained. Their term *zone* refers to what we know as values, and each zone represents a one stop change in speed or aperture. They are aware that light meters are designed to give correct speed and aperture settings for the

FIGURE 24

FIGURE 25

33

FIGURE 26

FIGURE 27

34

recording of objects within their field of acceptance at a fifth value (zone five). This is also known in photography as 18% reflectance. Zone system photographers *place* principle areas of their composition at different zones in order to render them at their *known* values and to previsualize the print. For example, in the case of a portrait of a girl in direct sunlight, the known reflectance value of her illuminated skin is six. The meter reads it as 5 and advises shooting at 125, f/16. The face is *placed* at zone six. This changes the speed/aperture calibration to 125 at f/11 or 60 at f/16. (To change a zone or value to one higher value, just open the aperture one stop more than the meter recommends, one lower number f-stop, or set the shutter at one speed slower). Completion of the zone system involves longer development for short contrast ranges between the darkest and lightest values of the scene or shorter development for long contrast ranges. (The painter can make these modifications with paint.) Any variation from the meter advice should be noted for evaluation after the prints are examined. These are listed as Estimated Speed (E.S.) and Estimated Aperture (E.A.).

If these basic camera mathematics disturb you there are two easier methods of achieving correct exposure. The first involves carrying an extra piece of equipment, a piece of cardboard that has been painted a neutral fifth value gray. It should be large enough to fill the viewing window of your camera for a light meter reading. Use Liquitex's acrylic fifth value gray to paint the cardboard and

FIGURE 28

FIGURE 26
Dominantly dark composition will be recorded as dominantly fifth value unless you place the shadows in a lower zone.

FIGURE 27
Same subject with shadows placed at zone two.

FIGURE 28
It's a nuisance to carry, but a fifth value gray card will ensure accurate value reproductions.

FIGURE 29
Good holding position for horizontal shots.

FIGURE 30
Good holding position for vertical shots.

FIGURE 31
*Bracing yourself on your elbows may help to steady
your camera. Here the author uses a birch fence rail.*

use photos for reference. For dependable accuracy, my advice is to purchase a camera that has *split image focusing.* In the center of view finders of this method is a small circle which will show straight lines as broken if the subject is out of focus. A turn of the focusing ring will straighten the broken line and, when it is straight, the focus is accurate. Other cameras place too much dependence upon your individual capacity for visual acuity.

For minimal camera movement hold your camera, as shown in Fig. 29 or Fig. 30 . It is best to brace yourself against a wall, or rest both elbows on a hard surface. As when shooting a weapon, squeeze the plunger gently until it activates the shutter release.

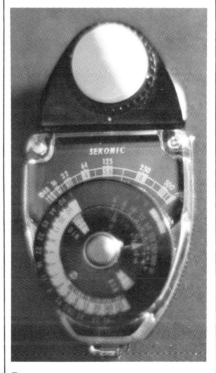

FIGURE 32
A light meter.

spray it with a matte fixative to eliminate gloss. Whatever your lighting situation may be, hold the gray card up, tilted just enough to eliminate reflection and take your meter reading from it. Since the reflected light meter is geared for zone five and you know the value of the card to be zone five, you'll get an accurate reading that will place all values of the scene at their proper relationship. A substitute for the gray card is illuminated grass and dirt. Some photographers get their speed and aperture reading by pointing their metered cameras at the ground!

Another method is to use a totally different type of meter, called *incident.* These meters do not measure light that is reflected, but rather measure the light that is falling upon the subject. Incident light meters are used by movie photographers to compensate for light differences when actors move from one lighting situation to another totally different one. Flash meters used by commercial photographers for photographing models under high intensity strobe lights are incident light meters.

Focusing is a critical consideration for artists who wish to

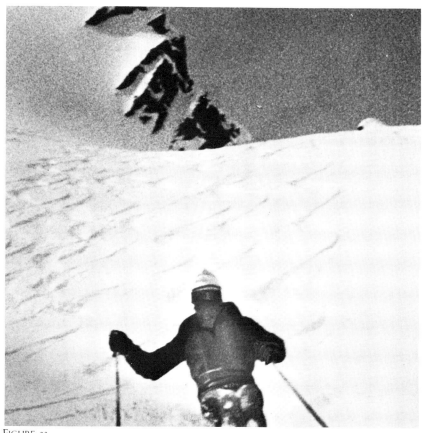

FIGURE 33

FIGURE 33

For a while, stick to black and white film rather than color. Your first exposure to the classical academic manner of painting will be involved with underpainting monochromatically and the black, gray and white values of prints you get from these films will be vital reference. You have three basic choices of film, each serving a different purpose.

For finest detail and greatest contrast, important for enlargements, *Panatomic X*, ASA 32, is the slowest of the currently popular Panchromatic films. It has a very thin emulsion and shows practically no grain. Good for portraits of women and children and for photos which feature texture in a broad range of values.

Another fine detail slower speed film is the orthochromatic Minox, ASA 12, great for male portraits, as it darkens the red in the flesh. Orthochromatic film is insensitive to red, recording spectral red as black.

Tri-X Pan, ASA 400, is the best hyperpanchromatic film (ultraspeed) for high contrast situations such as snow and beach scenes. It is good at picking up more shadow detail, and it is best for low light situations like shooting indoors without flash. This film is also most suitable for fast action photography. Its only disadvantage, some feel, is its heavy grain.

Grain refers to black, white and gray values shown as small dots in juxtaposition rather than as solid masses.

In between, there is the flexible *Plus-X*, ASA 125, suitable for outdoors or indoors, with a medium grain, not noticeable until greatly magnified. This is also a *panchromatic* film, which identifies it as one which records all colors in values of gray, although the value representing red is about three values darker than it should be. To lighten the gray value of red objects, a yellow or orange filter should be attached to the lens. A red filter would make red objects too light, but this can be used in some cases.

FIGURE 34

Filters are an important accessory for the artists who plan to use photography as a source of reference. With filters you can dramatize photographs to give them more visual impact, you can erase wrinkles and freckles, lighten a model's eyes or hair, change a daylight scene into an evening one, etc. Generally speaking, you can lighten the value of any object recorded on black and white film by using a filter that is the same color as the object. Conversely, a filter that is complementary or opposite in color to the photographed object will darken its value. The size of the filter for your lens is usually given on the lens as a millimeter size preceded by a symbol that looks like a zero with a slanted line running through it, i.e., ϕ52mm means that your lens accepts 52mm filters.

The yellow/red freckles of a model can be eliminated with a *red* or *orange* filter. Bear in mind that they will also pale the lips, and lighten the hair if it is reddish brown. These filters darken the sky almost to black; a slight underexposure with a red filter can turn a daylight scene into night time; a red filter is great for cloudscapes, landscapes with great distance (haze is eliminated) and whenever you want to lighten red or orange objects, or when you want to darken objects that are in the blue or green family.

Green (Wratten X1) increases color contrast but softens light contrast. Use it for portraits where the light is behind the subject, for lightening green leaves (especially if they frame red roses) and for outdoor portraits, to intensify complexion reds.

A

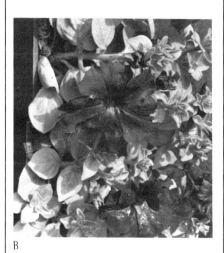

B

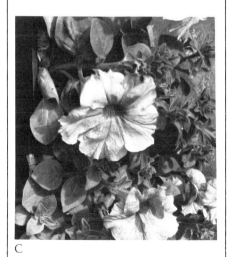

C

A *yellow* or *yellow-green* filter (Wratten K-2 #8) is the best all-round accessory, as it darkens skies (though less than red or orange filters), enriches complexions by darkening cheeks, is great for sunsets, snow scenes and pictures taken at the beach and whenever you want to increase contrast, lighten yellow or yellow-green objects, and when you want to darken anything in the blue or purple family.

The blue filter has a double use. For black and white photos it lightens anything blue (like dark snow shadows and blue eyes) and darkens anything yellow or orange. It also increases haze in landscapes and lightens blue skies and blue shadows on distant mountains. Since the color of deep water is a reflection of the sky, a blue filter would also lighten water (devoid of sediment or warm colored minerals). For color photography, you could use the same 80-A filter for shooting photos indoors with daylight color film, using floodlights rated at 3200 degrees Kelvin (a temperature measure).

A polarizing filter is also useful. By pointing it at a place in the sky that is ninety degrees to the sun and rotating it you can darken the sky a few values, with black and white or with color film. In addition, the polarizing filter can eliminate reflection from most glossy objects, including reflections in water and portrait highlights that you might find annoying. To find the optimum angle, spread your thumb and forefinger so that they form a right angle and point your thumb at the light source; your forefinger will then point toward the optimum area for

FIGURE 36

Bracketing examples. Top shot at meter recommended reading; next shot one speed stop more; third shot one speed stop less. Best shot came one week later, when the barn collapsed!

A

B

C

D

direction of your camera and its polarizing filter.

I mentioned before that there will be no need to adjust your meter reading when using a filter, if that reading is taken *through the lens* of your camera. If you use a hand held meter, an adjustment must be made in your speed or aperture reading to accommodate for the blockage of some light by the filter. There will be a number on the filter followed by an X which is a guide for the adjustment. Here's a simple chart:

TABLE 1

Filter Color	Factor	Speed or Aperture Change
Red	6X	Two and a half stops
Orange	3X	One and a half stops
Yellow-Green	2X	One stop
Green	3X	One and a half stops
Blue	3X	One and a half stops
Polarizer	3X	One and a half stops

(Disregard if you meter through your lens).

The chart is general and will be applicable in most situations but there are variables to consider, i.e., the reflection characteristics of the subject, the quality of the light, etc. If you use a filter, you should

FIGURE 35

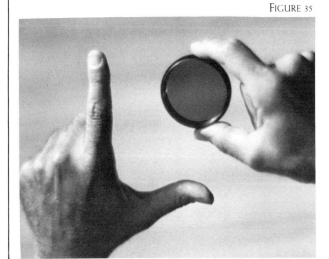

Find optimum area for polarization with right-angled thumb and forefinger as described in text.

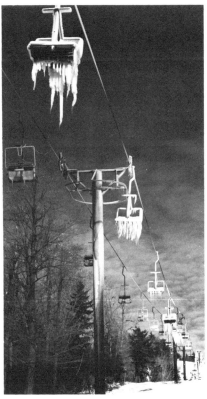

FIGURE 37

Yellow filter darkened the sky behind the chairlift at Bromley, Vermont just enough to emphasize the contrast of the icicles caused by snowmaking equipment.

FIGURE 38

A red filter can make a blue sky look black! The author photographed this group high atop the Purcell Mountains of British Columbia.

bracket your exposures. New photographers should bracket whether using filters or not.

Bracketing is a photographic term meaning to hedge your calculation by shooting one or two stops over and under the speed/aperture setting that you or your meter indicates. This will ensure a good shot. Film is cheap if a good photo is at stake. For example, metering through the lens with your speed set at 250, your meter advises an aperture opening of f/8. Shoot at that setting, then *bracket* by shooting with the same speed at f/5.6, f/4, f/11 and f/16. Five shots to get one good print is not an unreasonable investment.

There are many lenses available for your SLR. For the beginner a *normal* lens (50 or 55 mm) plus an extender or tele-converter (a poor man's telephoto) will serve well. The extender is attached to your camera behind the lens. It doubles the focal length (distance from films to the optical center of the lens, when the lens is focused at infinity) and thus magnifies the image, i.e., an extender behind a 55mm lens modifies it to a 110 mm lens. The difference between that combination and an actual 110 mm lens is a great deal of cost but little noticeable sacrifice in quality, particularly if you use a tripod to steady your camera. If your budget allows, a wide-angle lens, about 28mm, for shooting panoramic scenes will be useful. A wide-angle lens permits great *depth of field.*

Depth of field refers to the amount of the scene that you see through your viewfinder which will be in sharp focus. This is easily determined, after focusing, by reading a third set of numbers on

FIGURE 38

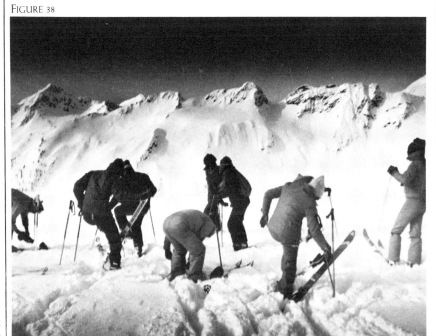

41

your camera. They appear on the lens, just behind the focusing numbers, which are indicated in feet and in meters. You'll notice that the depth of field numbers are repeated on either side of a diamond or line. Once your aperture opening (f-stop) has been set, in accordance with your meter's specifications, find the same number on the depth of field scale, to the right and left of the divider. Look straight upward from those numbers and you'll see the number of feet away from the camera which will be in sharp focus.

Film is labeled with an ASA number. This refers to the speed of the film (ASA comes from American Standards Association). Low ASA numbered films need a lot of light, while high ASA films are faster, needing less light. The ASA number *must* be properly set on your camera before shooting for assured results. A dial for this usually appears near the plunger on your camera. Your camera manual will advise how to set it. Unfortunately, not all cameras are tuned to the ASA of all films. For this reason, it is wise to take some test shots for comparison. Use the form provided to keep track of your experiment.

Begin with Panatomic X, ASA 32. Pose a black, a white and a gray object, with one of those values covering a dominant space. Set your camera at ASA 32, and take one shot at the speed/aperture setting recommended by your meter. Record the information on the form next to picture number one.

Next, use the same speed/aperture setting, but change the ASA number to 20. Take the same shot. Follow by changing the ASA number to 50 and fire again. Record each shot on your checklist.

Complete the roll of film in the same manner, shooting a variety of subjects, using filters for some, but bracketing the ASA number as directed and recording all on your checklist. When the roll is finished and you have it developed, ask for a contact sheet of prints. This is a direct print from your negatives, from which you should be able to determine whether your camera is in tune with the ASA of the film. If it is not; if the photos shot at ASA 20 look better than those shot at 32, you will have to change its ASA rating. Your new number, specifically for *your* camera is called your Estimated Index (E.I.). You'll notice a column for it on your checklist. Try the same procedure with other films of differing ASA indexes.

Use the checklist every time you shoot a new roll of film and you'll soon become very familiar with your camera. Creative composition will be explained in a later chapter. After you have read it, you might want to use another form or checklist to guide your photographic efforts in the compilation of visual reference material for significant paintings.

Lighting is the most important consideration in photography, and since your art can be assisted by good photographic reference, you should know some basic techniques.

Available light is always the most natural form of lighting. The term simply means the use of illumination from a *natural* source. Sunlight is a bit harsh, creating sharp edged shadows that print too dark if you have exposed for the

Picture Number	Film	ASA	E.I.	Meter Speed	Meter f Stop	Zone	E. S. Speed	E. A. f Stop	Lens	Tele-extender	Filter	Lighting
1.												
2.												
3.												
4.												
5.												
6.												
7.												
8.												
9.												
10.												
11.												
12.												
13.												
14.												
15.												
16.												
17.												
18.												
19.												
20.												
21.												
22.												
23.												
24.												
25.												
26.												
27.												
28.												
29.												
30.												
31.												
32.												
33.												
34.												
35.												
36.												

FIGURE 39
Photo reference checklist I.

Picture Number	Unity Achieved Through Dominance of: Line	Direction	Space	Shape	Texture	Value	Color
1.							
2.							
3.							
4.							
5.							
6.							
7.							
8.							
9.							
10.							
11.							
12.							
13.							
14.							
15.							
16.							
17.							
18.							
19.							
20.							
21.							
22.							
23.							
24.							
25.							
26.							
27.							
28.							
29.							
30.							
31.							
32.							
33.							
34.							
35.							
36.							

FIGURE 40
Photo reference checklist II.

light values of your subject. Photographers have a common expression, "Expose for the shadows, develop for the highlights . . ." This is their way of advising us to take our meter reading (zone 5) off the shadow of our subject (which actually may appear to be in zone three) and shoot at the recommended speed and aperture reading, or stop down by shooting at zone four (one stop less light). Thus, if a reflected light meter pointed only at the third value flesh shadow suggested 250 at f/8, you would shoot at 250, f/11. This would lighten the shadow one value step to a fourth value and darken the light areas one value step, but, if the entire values of the scene ranged from one through white (a long contrast range), shorter development would get greater detail in those light areas, and guard against a whiteout.

Leonardo suggested avoiding sunlight for portraits and his advice still applies. Portraits under overcast conditions or those painted or photographed under light devoid of sun are best because the lighting contrast is not as great and the shadow edges are much softer. With color film, though, north light is quite blue, so an orange filter is indicated (try a Wratten 81B). If you're shooting a portrait in black and white outdoors on an overcast day, a green filter is recommended to accent a swarthy complexion or rosy cheeks, and a yellow or orange filter will lighten the skin. One of the great advantages of using photography as reference for paintings is that you can manipulate values and show off your model to his or her best advantages before you have even touched your paints!

Available light indoors would refer to light from a window (sufficiently diffused for soft edged shadows), firelight, candlelight, etc.

Artificial light encompasses flood or spotlight from tungsten or incandescent sources, fluorescent, flash and elecronic flash, often called strobe. While fluorescent light does produce softer shadows than the brighter incandescent or tungsten sources, it is only suitable for black and white shots unless a CC filter (made exclusively for fluorescent light color correction) is used.

Best for strong dark and light modeling is floodlighting or spotlighting with incandescent or tungsten bulbs. (An incandescent light has a tungsten filament.) The term *flood* simply means light that spreads over a large area, differing from a spotlight which is shielded to a beam at a small area. Tungsten lights may be used with certain indoor color films only if they include a gas called *halogen*, otherwise the incandescent bulb must have been dipped and colored blue. Blue floodlights may be used with daylight color film like Kodacolor II for excellent skin coloring (I prefer 500 watt).

For your first experiences try two 500 watt floodlights, one 500 watt spotlight and telescoping light stands with reflectors. The cost for these is nominal. You may use these bulbs for daylight color film if you also use a blue filter (80A), to cut down the warm influence of incandescent lighting. An *umbrella reflector,* available at most camera

FIGURE 41
Spotlight throws a narrow beam of light, whereas the floodlight's spread of light rays is wider. For a narrow diameter spotlight try the trick shown on the right—tape two reflectors together.

FIGURE 42

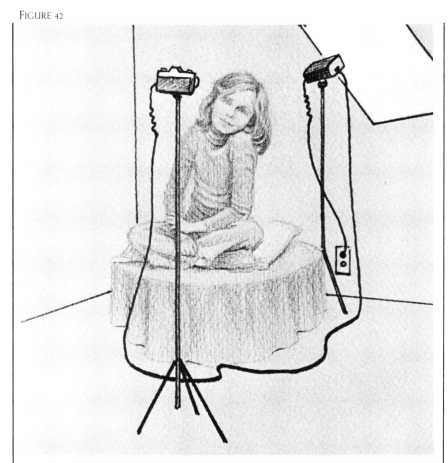

FIGURE 42
One lighting setup for a portrait. Flash is bounced off reflecting poster board and off opposite wall.

FIGURE 43
Photo taken with lighting setup shown in Figure 43. Model is Covino's daughter, Cami.

FIGURE 44
Lighting setup for Phil Patricca. Only one spot, with a black draped background.

FIGURE 45
Photo taken by the author of Phil Patricca.

FIGURE 43

stores, is an excellent tool for bouncing light from the primary source into the shadows.

Dramatic Rembrandt-esque portraits can be created with only one floodlight in a relatively dark room. Figure 44 shows the setup for my ultra-masculine shot of Phil Patricca from which his wife made a beautiful portrait in class.

Experiment with different lighting situations. You could illuminate your subject from either side, choose to illuminate the background or let it go dark, flood a wrinkled face directly to hide the lines or hit it indirectly to accent them. Allow your principle lamp to be closest to your model, to function as the primary light source. A secondary lamp of equal wattage should be beamed at your model from the shadow side, but two or three times farther away from the model than the distance between him or her and the primary light.

With floodlighting, spotlighting, available lighting or outdoor natural lighting, remember that your reflected light meter is designed to give you an optimum speed and aperture reading only if it is pointed directly at something that is a fifth value, and only if that object fills the total field of acceptance. That means, if you take your reading from a fifth value gray card

FIGURE 44

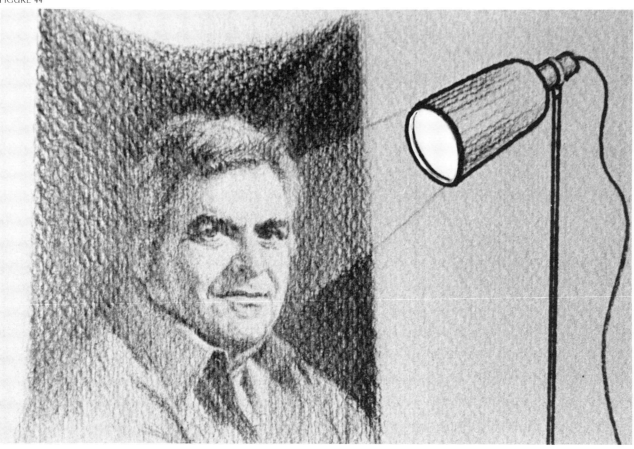

FIGURE 45

with a light meter that is built into your camera, the gray card must fill the viewing area of the camera when you observe the calibration. An easier method is to use an incident light meter, held at the position of the model.

If you choose *flash* as your lighting, off camera electronic flash (called strobe) is best. Flash units mounted on the camera are unsuitable for the painter, as they illuminate the model from the front, giving equal illumination to side planes as to front planes. This makes faces look wider and heavier, creates black shadows that hug the model and is most unnatural.

Off camera, placed in strategic positions such as those recommended for floodlighting, strobe is the best form of artificial lighting. It is the fastest, allowing you to stop action and creating super sharp images. It is as bright as daylight, so it may be used indoors or out without a blue filter. Because it is turned on for only a brief instant, you and your sitter can be a good deal more comfortable during the shooting session (no heat), and a flash meter working as an incident light meter will accurately measure the light that falls on your subject, giving you correct speed and aperture advice for a good picture.

Multiple flash units may be ad-

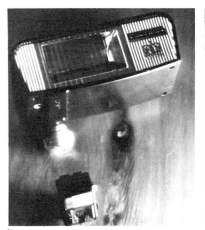

FIGURE 46

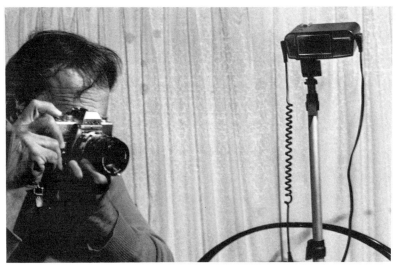

FIGURE 47

FIGURE 48

justed to function at the same time. A plug, called a *slave*, is simply plugged into an additional strobe; the slave is highly sensitive to light, so it activates the strobe into which it is plugged the moment it receives light from the primary light source (the strobe closest to the model). To remove the principle strobe unit from the camera, a PC extension cord is used and the unit is mounted onto a stand which is topped with a universal *hot shoe*.

The only annoying thing about multiple flash photography is that the photographer cannot see the final result of his lighting set up until the prints are developed. Wise photographers mount a floodlight close to the strobe in order to paint the face of their model with light and shadow and preview the final result.

There is much more to photography and its procedures, but they are not the purpose of this book. Our priority is the mastery of painting in the classical academic manner. Recognize the camera as one of your tools. Give photography as much time as you give to sketching; both are vital activities in the complex creative process.

FIGURE 46
Slave plug and flash connector. Exposure of the slave to another flash will trigger it instantaneously.

FIGURE 47
Flash off camera, connected by PC cord.

FIGURE 48
Floodlight clipped onto flash light stand will allow you to shape your shadow areas.

II | The Science of Accurate Drawing

Drawing, to most people, will always be the magical mystery it has been for centuries. What is it that allows some to be able to put down on paper accurately what they see, while others can't seem to draw the proverbial "straight line with a ruler"? Is there a kind of transcendental linkage, spiritual blessing given to a chosen few? Some people call it *talent*, but when we break down talent more specifically we find it is comprised of several quite common human characteristics each of us has or is capable of acquiring: patience, discipline, a capacity for accurate observation, recall and sensitivity. Some people are born with an abundance of these characteristics, but even they need specific guidance to properly master their craft. The traits listed add up to *potential* for artistic expression but such potential is likely to remain dormant without direction.

Even the gifted child must be guided. While the practicing artist can be innovative in his manner of artistic expression, that expression is always influenced by what the Italians call "schemata." This roughly means a form of expression we accept as truly representative of an object, a feeling of a person. It is, therefore, a form we choose to imitate in our own effort to reproduce the same image. Parents often witness a child's pride when they produce a sketch of a person. Usually, it is a stick figure with a lollipop head. Nobody looks like that, but the child labels it Daddy or Mommy, or perhaps gives it the name of one of her friends. Where did she pick it up? We are certainly not born with stick figures in our head. The child probably saw such a drawing at school. A teacher might have drawn it on the blackboard. "Let's draw a person" might have been her direction. Then, "Make a circle for the head... Now a line for the body... One for the arm... Five small lines for the fingers...," etc.. A schemata. If the child is not observant, if she is not curious and courageous enough to challenge her teacher's simplistic representation of "a person," she might go through the rest of her life influenced by that schemata and may never represent a person in any other form! In this respect, an art teacher's challenge is confrontation with inaccurate schematas that influence a student's representation of a form.

Consider the drawing of an eye. Every semester at least one of my students draws the eyes of the subject with two perfectly symmetrical curves, the familiar pointed almond shape. A schemata. He could have a clear photo of the subject in hand, stare directly at the eye of the model, which is obviously peaked off center and above the iris, and yet sketch it as symmetrical as a football. That's a schemata at work. Somewhere in that student's background someone said, "This is how to draw an eye," and the schemata was never altered.

Assuming that you as an art student are interested in painting things as they truly appear: The first thing that must happen is to rid your mind of inaccurate schematas that influence your artistic expression. As your teacher, I must help you to *see* things you have merely been looking at. You must become an accurate observer, a

FIGURE 49
Comparing well-sketched eye to one sketched by schemata.

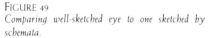

A

B

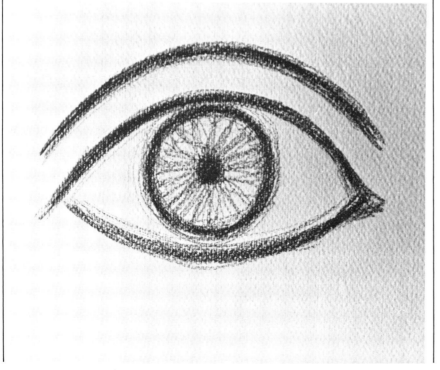

visual perfectionist. In devoiding yourself of inaccurate schematas you open your mind to the excitement of acute, representational perception.

Drawing usually starts with a line. But, there is no line in nature. What we usually think of as line is in reality the division between forms. Line is of little value to the painter who must learn to see in terms of light and shadow. The tool of the painter is *value*, the science of shadow and light, or what the Italians call *chiaroscuro*.

If you have had experience in

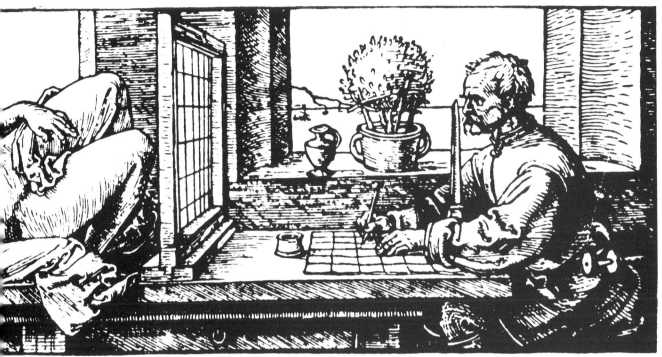

FIGURE 50
*Woodcut by Albrecht Dürer (1471 - 1528)
Students of the Renaissance learned to draw by
beginning with the graph.*

sketching and want to learn how to paint, you should forget about the point of your charcoal and instead use the broad side of it. You should begin to think only of shadows, shapes and edges. Light and shade can be measured in precise value on a scale from zero to ten, or from black to white. When you begin to think of values, you will be thinking as a painter. The artist's job is to create the illusion of a three-dimensional form on a two-dimensional surface. We perceive that form mainly because of light and shadow.

Most students have had little experience with drawing and their knowledge of proportions is limited. Proportions deal with measure, and measure is best taught with line. So this is where we'll begin our discussion of drawing with accuracy.

There are two types of line, *straight* and *curved*, plus four different directions, *vertical, horizontal, right* and *left obliques*. In sketching with line, the first thing that separates the accurate artist from the amateur is the ability to perceive the variations the con-

tours of his subject take from these standards. Imagine a head tilted to one side of absolute vertical. Let's assume we are drawing a person's head. What is it that permits one artist to see precisely how many degrees away from vertical is the tilt and another to misjudge the angle by several degrees?

The Masters of the Renaissance had to face the same problem of visual acuity and manual dexterity with their students as serious art teachers face today. The Masters solved it with a device which seems cumbersome to us,

but it provided a specific control to guide the student's line sketch. Strung from an empty wooden frame which was a larger but similarly proportioned size than the student's canvas were twelve vertical strings and twelve horizontal strings. This *graph* was placed on a table between the student and the model. A piece of wax was placed on one of the strings at the key location to ensure correct alignment between sittings, i.e., if the model was a nude, the wax might be placed on a string at the navel, and each time the student returned to his painting, he would position himself so that the wax would cover the same spot. The instructor could also take the seat of the student and ensure the same visual alignment. Surely this is a better system than the one so prevalent in many art schools today where the instructor takes the pencil or charcoal from the student's hand and redraws an incorrectly sketched line saying, "No, it should be more like this..." you learn nothing from such tutorage other than an assessment of the teacher's ability.

The precise tilt of a model's head away from absolute vertical might be a difficult perception for an amateur. That difficulty can be minimized considerably if a vertical line is placed next to the model. The assessment of precise tilt becomes even easier if the negative space as well as the form space is considered. (The negative space would be the space between the vertical line of the graph and the contour of the form.) It should be emphasized that this grid was a teaching device used by the Masters to train the perceptual

capacities of their students. Periodically, it is said, the Master would snap off one of the strings of the grid until, eventually, his student was sketching "free-hand." Try constructing a drawing device for working "from life." You'll find it good discipline. In my classroom, the graphing procedure is used over photographic reference, when a student is seeking precise reproduction, as in the case of a portrait.

Purists might argue that the device is a form of "cheating," or that it stifles the creative process. This is baseless. The creative process begins with the original idea. That is followed by a plan for composition. Photographic reference and devices for accurate reproduction are merely tools for implementing the original conception.

My experience with students over a twenty year period has indicated that the graphing method *can* teach almost anyone how to draw. Perceptive acuity is more acute in some people than others. You might be one of the lucky ones who has a "natural" knack of seeing with precision. Don't despair if you are not. The ability to portray accurately what you see is a cumulative capacity and is learned through repeated effort.

It is not enough to be able to see; you must learn to translate your perception into some graphic form of expression. You'll need to learn a sophisticated form of schemata. The best method has a scientific basis. Such an approach produces a constant result from a specific form of measure. In truth, academic drawing is little more than measuring. If you can measure, you can learn to draw.

All you need is the desire, the patience and discipline.

Remember, you can sketch a tree fatter than it is and it will still look like a tree, but you can't do that with a nose, if you want to create a realistic portrait. If you have difficulty with accurate drawing, the graph might be for you. Directions for using it follow below. One word of caution: learn to take your own photographs. If the reference from which you work is your own, you may safely call your work your own. The camera should just be another of your tools. Using someone else's photo is not a good practice.

Graphing procedure for accurate enlargement

1 On a clear piece of acetate with a permanent ink black marking pen, draw a rectangle close to the size of your photograph that is in the same proportion as your larger panel or canvas. For example, if your panel is 16x20 inches, the rectangle on your acetate might be 8x10 inches for a photo 7x9 inches; 16 is to 20 as 8 is to 10. The rectangle on the acetate should be close to the size of your photographic reference. Use a right angle to ensure the squareness of the corners. Related proportions are easily listed by dividing in half as follows:

16:20		1 1/2:1 7/8
8:10	Ratios	3:3 3/4
4:5	may also	6:7 1/2
2:2 1/2	be added	12:15
1:1 1/4	together.	24:30
1/2:5/8		Etc.

FIGURE 51
The basic graph (draw these lines with a red mark-ing pen on a piece of clear acetate).

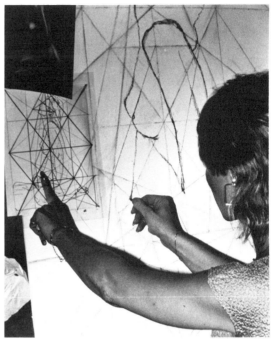

FIGURE 52
Beginning the sketch. Treat each space with ac-curacy. Forget the subject and think only of line. Work with your photo and your sketch upside-down to check your first decisions.

If your photo is a portrait, always consider the face length on the photo before you select a rectangle size for the acetate, in order to keep your painted portrait under life size. (Portraits painted over life size tend to look grotesque, no matter how well they're painted.) If the face on your 8x10 inch photo is already five inches, it would be a mistake to draw a rectangle on the acetate 8x10 inches for a 16x20 enlargement, as the enlarged sketch would then provide a ten-inch face; much too large. As a general rule, a man's face should not be painted larger than 7½ inches, from chin to average hair line; a woman's limit would be 6½ inches and a child's 5½ inches. Thus, if a man's face in your 8x10 photo is 3½ inches, it would be safe to draw an 8x10 rectangle on your acetate for a 16x20 enlarged sketch; for a 4 inch face on the 8x10 inch photo, a rectangle on the acetate 10x12½ inches would be more satisfactory for a 16x20 enlargement. The small amount of extra space around your photo must be filled in with a continuation of the form, of course.

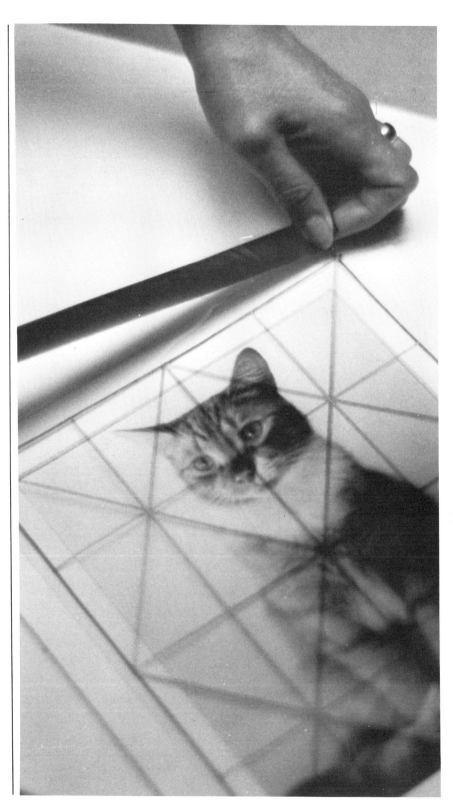

FIGURE 53
Tape the photo to the graph to prevent slippage.

2 Divide the black line rectangle you have drawn on your acetate into quarters with verticals, horizontals and obliques as shown. Use a red permanent ink marker. Begin with a large X from corner to corner. Then, divide the rectangle in half, vertically and horizontally. Next, a diamond shape, connecting the vertical and horizontal lines. Finally, add the two pairs of verticals and horizontals that quarter the rectangle. This we'll call the Basic Graph.

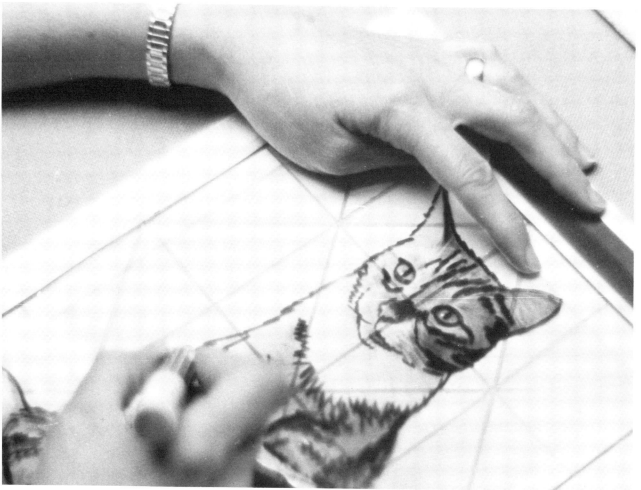

FIGURE 54
Trace the features of the form with a black marking pen. This is not intended to be a great drawing; it is merely a guide for study of feature placement.

3 Tape your photograph in position beneath your basic graph. With a black marker, trace the contour of the form, all the important features, and mark the shadows with a dotted line. Then remove the photo.

FIGURE 55

Additional guide lines may be drawn in another color marking pen. These are seen as lighter in value on Lillian Olsen's tracing. They should be rendered in a different colored pen to avoid confusion.

FIGURE 56

Gesso both sides and the edges of your masonite panel to seal it from moisture. Use a paint roller, not a brush, for an evenly spread textured surface.

4 To avoid confusion in the drawing process that follows, use a marker of a different color and draw additional lines close to the features of the model. These guide lines may be drawn from any point where two red lines cross or from any terminal point of a red line at the borders of the rectangle on the acetate.

5 Your panel or canvas should be coated generously with gesso. It is best to use untempered masonite, as it is least susceptible to weather changes and other deleterious effects. The slick shiny surface should be sanded with rough sandpaper to make it absorbent prior to the gesso application. If a soft thick haired roller is used to apply the gesso, the affect will be a fine pebbly surface or what professionals call tooth. The first coat of gesso should be thinned with water for greater adhesion. Some brands of gesso are already thin. They require three or four coats for proper coverage. A superior brand, Utrecht, requires only two coats over the thinned first coat. The back and sides of masonite supports should also be painted with gesso to prevent warpage.

FIGURE 57
Dust the guide lines to make them appear lighter,

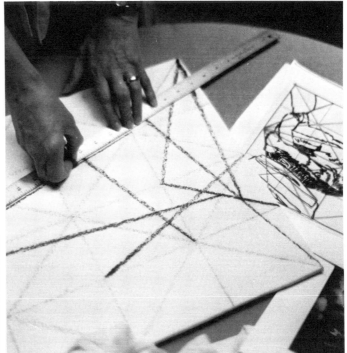

FIGURE 58
Adding additional guide lines.

6 Begin your sketch with a stick of hard grade vine charcoal, drawing on the gessoed panel the red lines that you made on the Basic Graph. Start with a big 'X' from corner to corner and follow the same sequence that you followed on the acetate. When the Basic Graph has been marked, dust off the charcoal lines with a rag until they are faintly visible.

7 Boldly mark with charcoal the additional guide lines which appear in a different color on your acetate. Then dust these until they also become lighter.

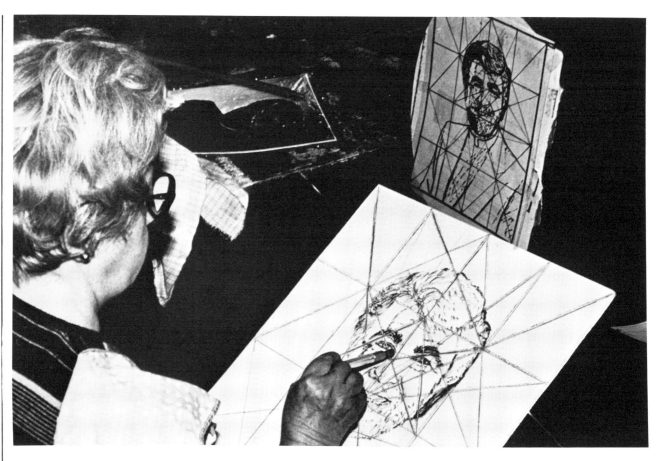

8 When all of your guide lines have been dusted to make them faintly visible, begin your sketch, again with a bold mark of the charcoal. Try to divorce yourself from the subject matter and think objectively of the lines of the form in relation to the guide lines. Work slowly, box by box, studying the negative space shapes as well as the positive shapes. Check your accuracy by periodically inverting both the acetate tracing and your charcoal sketch. They should look the same from every angle. Corrections can be made with a kneaded eraser or by scraping lightly with an X-acto knife.

9 When your panel or canvas sketch looks exactly like your acetate tracing, enlarged, you are ready to put away the acetate and being working with gray values from your photograph. You'll be working with the confidence of knowing all the features are in the right place. Begin by toning your background; it will be easier to discern the values of the form when the area beyond has been toned appropriately. Scribble with your charcoal and smudge with your fingers to create the desired tonal effects.

10 With a finger, darkened by the smudging, try to reproduce the

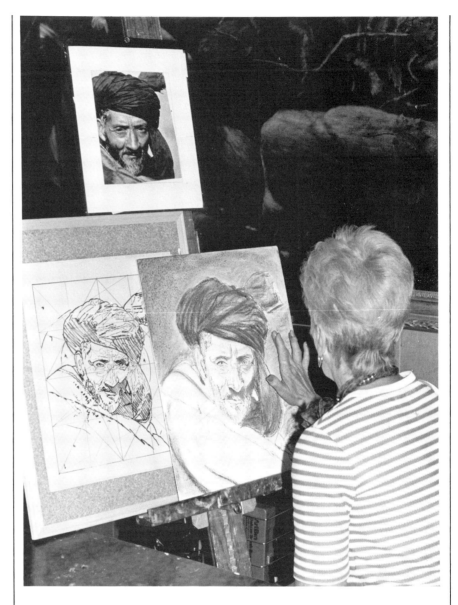

tones of the form as seen in the photograph. Bear in mind the limitations of charcoal. Don't expect to be able to recreate a perfect value study. The full range of values will be easier to recreate in paint. The primary purpose of this charcoal rendering is to place the features accurately and to indicate the basic values. When you have taken the sketch as far as you can and are satisfied with its accuracy, spray it with a good grade of retouch varnish. You are now ready for paint.

The graphing procedure will help you to recreate and enlarge the things you see, either live, or in photographs. As exacting as these methods might be, they are but graphic variations of the same method used in free-hand drawing. If you watch an artist working free hand you'll see he is often drawing imaginary vertical and horizontal lines before his subject. He frequently makes estimates which forms lie beneath other forms in direct vertical alignment; he compares the width of some features

FIGURE 60

The finger is an excellent tool for adding shadows. Sherry Minor, a diligent student, demonstrates the birth of a painting.

with the length of others, etc. In fact, he tries to view his subject through an imaginary graph. Training with the method outlined here can lead to the ability to draw in a free-hand manner. I am certain of it. The system works.

This is not to say that the professional cannot also profit from use of the graphing procedure. Illustrators who are pressed for time with deadlines could profitably use the method. Or they may employ a more mechanical device called a "Lucy," or another type of projection device.

When I was a student at Pratt Institute, a free lance advertising artist friend of mine asked if I would be interested in a commission to paint Pope Pius XII. I was thrilled at the opportunity, of course, and had visions of my portrait ending up in the permanent collection of the Vatican! Rudy went on to describe the particular requirements, "A portrait of the Pope flanked by two Papal Seals, 40x100...," he paused "...feet!" You can imagine my reaction. They wanted this giant portrait rendered on hundreds of 30x40 inch cards which would be hooked together by followers seated in the bleachers of the Polo Grounds at a birthday celebration.

My "studio" was a 5x10 foot porch in my parents' home, but I needed the money, so I took the commission. What followed was my first use of the graphing procedure: Over a small painting of the Pope I superimposed a piece of acetate with a graphed rectangle in a related proportion to the final size. The spaces of the graph were smaller variations of the 30x40 inch cards. Each space was assigned a letter and a number. Each 30x40 inch card was then assigned a corresponding letter and number, and, one by one, they were painted. I never saw the finished work until it appeared in the centerfold of the New York Daily News the day after the celebration! The system works.

I hope I have taken some of the mystery out of realistic drawing and have reduced it to a manageable science. The ability to paint what you see is only the beginning of the artistic creative process. The true artist is more than a camera. He must select, modify and delete. And he must *compose*, with respect for sound design principles. Once you have learned how to portray that which you can see, you are ready for the excitement of creative composition.

III | The Science of Creative Composition

Plato visualized painters as imitators of things that already exist, recreators rather than creators, second class craftsmen rather than initiators or innovators. He relegated artists to ranks of secondary significance, and did not include them in the design of the Ideal Republic. If our purpose as artists is no more than to reproduce things that we see, then Plato would be justified in his exclusion of us in a contemporary community of *significant* citizens. After all, photography can perform the mechanics of reproduction capably, and the least educated individual can be taught how to push the button on an automatic camera. This judgement might sound strange, coming from an author who is trying to keep alive the ancient tradition of realistic painting in the Classical Academic manner, but *learning to paint with verisimilitude is only the beginning of our craft.* You might compare it to learning the notes and chords on a piano. The creation of beautiful music is the end toward which the means of note and chord study are directed, and the creation of beautiful art is the goal toward which learning to paint things as they appear is prescribed.

Notes and chords must be arranged in an orderly manner with the motivation of eliciting a specific response from the listener (this is the communicative aspect of art in music). Artistic music has a mathematical basis with attendant relationships that strive for *unity.* Such a mathematical foundation relates music to Classical Academic painting.

I will never forget an incident that drove home this awareness some years ago. My diversified interests led me to become sufficently proficient in skiing to become an instructor. One fall, I travelled from coast to coast with the International Ski Shows, a trade fair for which I designed an audio-visual instructional program, using a film with classical background music and live narration. The music was from a Bach fugue, as its rhythm synchronized beautifully with the ski movements through powder snow. At the close of a performance in the New York Coliseum, I was headed to the rear of the auditorium to thank the projectionist for doing a good job. In the process of rewinding the film he accidentally forgot to switch off the sound control. I ran to the projector with such excitement that the poor guy thought I was angry. "I'm sorry . . ." he shouted, "I forgot to turn it off . . ."

"No!" I pleaded, "Leave it on. Leave on the sound! Do you hear it? Can you believe it?" The Bach fugue was just as beautiful played backwards! The mathematical relationship of the notes and chords was so carefully contrived, so beautifully designed that the system worked, even in reverse.

If the design elements I discuss in this chapter on Creative Composition are rendered with the same care in your creation of a painting, then it too should be as aesthetically pleasing, even upside down!

Since the appreciation of a

beautiful composition of music is temporal, musical unity is sequential. Therein lies the basic difference between the art form of music and the art form of painting. Both are carefully organized plans comprised of interrelated constituents and expressed in sensuous mediums, but music requires times for its audial appreciation while the visual response to painting is *spatial*. The appreciation of art in a painting is immediate since the medium appeals to the sense of sight. While the musician can take time to relate the bars of his music in his effort to unify his sequential audio composition, the painter must incorporate all the relationships he can in his single composition. Before defining these relationships and suggesting how you might use them to improve your work, allow me to point out that your primary motivation should be to create a communicative work of art that has *unity*, oneness, the constant characteristic of all great art, whether it be painting, writing, acting, dancing or music.

If the painter creates a work of art that communicates, that is indicative of superior craftsmanship *and* that has unity, then his creation is *primary*, singular and certainly significant enough to include him in any Ideal Society. It is not his ability to recreate forms he perceives that awards him this honor, but how he composes those forms in his effort to deliver a particular message; *creative composition* separates the weak artist from the artistic painter, although both may use representations of "realistic" forms in their works.

It is the difference between a Rembrandt portrait, in which the artist loses half of his subject's head in the unifying darkness of the background, and one of the monotonous photo realist's portraits currently in vogue, which are no more than a tracing of a projected photograph sprayed with the soft blendings of an air brush. The creator of the latter, his expeditious method notwithstanding, takes pains to reproduce every minute pore, every change in value that he has traced from his projected photograph. The Master's work, however shows a unity of color, texture and value relationships with the employment of *dominance* and design that elicit an emotion from his audience.

Dominance is the key to unity in art. The writer enlists a dominant character to carry a dominant message through his novel; the dancer employs one dominant movement to unify his aerobic performance; the musician begins his symphony with a dominant group of notes, then repeats them throughout his composition, striving for sequential unity; and the painter wields the tools of his craft with dominance in an effort to unify his creative composition. Specifically, the representational painter who qualifies as a creative artist may use realistic forms, but he selects, modifies and deletes in an effort to create a dominant *direction*, dominant *size*, dominant *shape*, dominant *texture*, dominant *value* and

FIGURE 61
Rembrandt van Rijn, **Greisenkopf,**
Schwerin, Landesmuseum

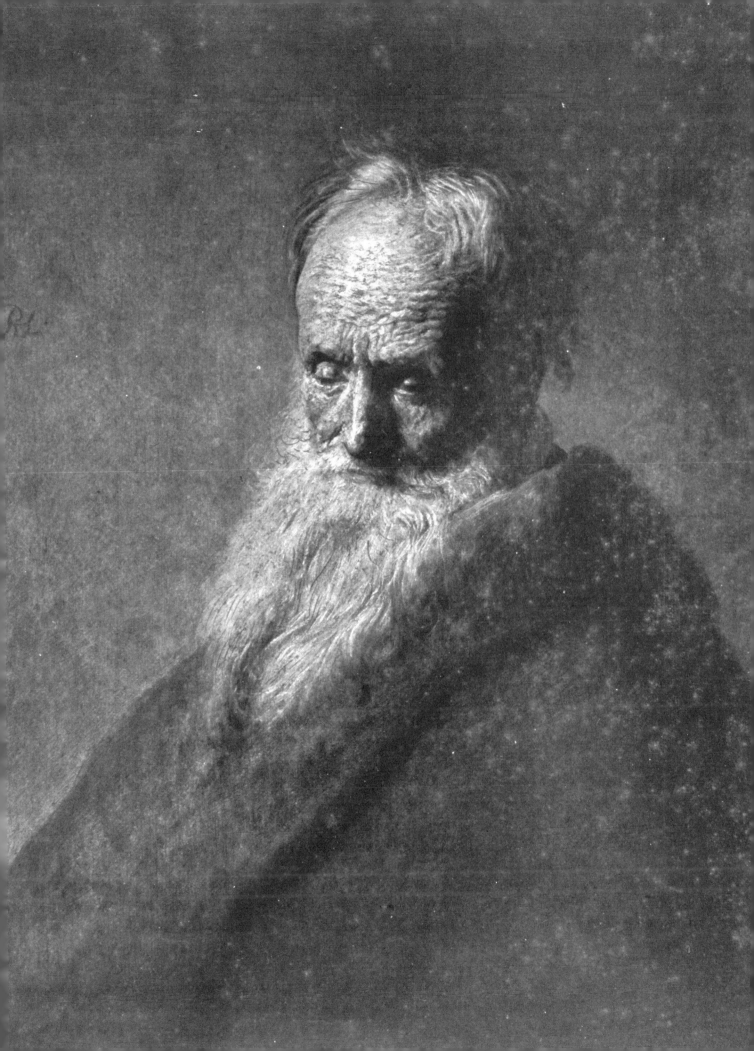

FIGURE 62

The lines of nature's trees are dominantly straight with some curves. They also form a dominantly vertical direction, balanced by their horizontal branches.

dominant *color* in his painting. The result of these efforts is a work of unity, much superior to the product of a camera.

Photographers might argue that these tools for creative composition can also be used by the cameraman, and the fine quality of some contemporary photographs can certainly support such a claim, but the fact that can't be denied is that the terminal photograph is the product of a mechanical instrument. It can be reproduced in volume by anyone employing the same printing process used for this book, while a good painting is a unique product, one of a kind, which can last for centuries. The photographer is also limited in his manipulation of color and values, and the slick surface of his photograph cannot begin to compare with the tactile surface of a painting which supplies another dimension.

Rather than look upon photographers as adversaries, realistic artists should learn to master the camera and use it for reference in their creative process. With photographs that I have taken, I will now illustrate the compositional tools listed with respect for dominance. Please remember photos should only be springboards in your reach for the ideal composition. Don't be a slave to your reference. Develop your own composition from several photographs, borrowing a tree from one, a mountain from another, clouds from still another. Use your power of selection, modify and delete until you are

satisfied with the completed work, such art will be more substantial because it will be a singular product of unique conceptual capacity. It will be a *primary* effort!

Dominance of line

While line is primarily the tool of the sketch artist or cartoonist, some paintings include forms that are quite linear. Just remember to design your composition so that most of the lines are straight, with a few curved lines complementing that dominance, or keep the lines predominantly curved, opposed by a few forms of straight linear character, as you might create with rolling hills and cumulus clouds backdropping an old barn, for example.

Be sure to avoid tangents when you compose. A tangent occurs when one form ends at the same spot as another. You'll get more depth and thus create a more convincing three-dimensional illusion if one form passes in front of another.

Lines can also draw attention to your focal point (area of visual emphasis) if you design the lines of your composition to function as directional arrows.

FIGURE 63

Tangent is formed by tree silhouette meeting vertical bridge support. Overlap would have created more depth.

FIGURE 64
Vermonter Eastman Long's sugaring equipment featuring a dominantly horizontal/oblique direction, balanced by the vertical bucket.

Dominance of direction

The shape of your panel or canvas establishes the dominant direction of your composition. You can enforce this dominance by incorporating elements in the design that follow a similar direction. In order for a composition to have a dominant direction it must also include elements that vary in direction with at least one element in total opposition. For example, Figure 64 shows a view of some sugaring equipment in Vermont that is horizontal. This horizontal quality is strengthened by the oblique log and wagon frame, but the term dominance implies the presence of other elements that are subordinate. If they were equal in volume or area to the dominant forms, there would be no dominance and the composition would be unsuccessful. Hence, the maple syrup bucket stands in vertical opposition to the dominant horizontal composition. By photographing the wagon at an angle, the backside of it provides a left oblique direction that contrasts with the side.

The phone by itself is a good composition, and an accurate reproduction of it in paint might be of interest, but nothing would be left for the spectator's imagination. Andrew Wyeth could take photographic reference such as this, select a focal point, perhaps the bucket, develop it with egg tempera and enlist the spectator's imagination by treating the other composition elements with less emphasis.

FIGURE 65

FIGURE 66

Psychologists have revealed that the average human mind will not accept incomplete images without making a mental or physical effort to complete them. Try a simple test on your friends. On a piece of paper, sketch several shapes like those shown in Figure 65 and ask them to study them and reproduce them on a separate piece of paper. What will probably result in a copy of those forms that looks more like those seen in Figure 66. The small openings are incompletions for which most individuals will not have tolerance. Film makers of the past took advantage of the closure principle by fading romantic scenes before their inevitable climaxes, and audiences were delighted to complete the emotion in their own minds. Imagination can be far more exciting and intense than total exposure. The closure principle is also a standard tool of the novelist and the poet.

Rembrandt was a master at the employment of closure; most of his later paintings invite the spectator to complete forms which are lost in dark shadow. We comply. It is one of the most difficult ploys in the painter's bag of tricks because he also is susceptible to the natural human proclivity for completion.

Art teachers find it difficult to convince students that a diffused suggestion is more effective than a precise rendering of individual hairs, etc. The Pieta of the young Michelangelo is a brilliant example of fine marble craftsmanship, but its shining detail looks plastic and uninteresting when compared to the Master's later works which show partially finished forms emerging from the rough marble. We bring our minds to the latter and it is this act of imaginative completion which encourages the intellectual spectator to appreciate the work of art more.

No one is more guilty of surrendering to the closure principle than I. I have to fight my subconscious with every painting, as it pushes me to add more detail to my work. It is a battle, but I'm getting more courageous with age.

It took Rembrandt many years to escape his tendency of closure. Look at his early works and you will see an incredible amount of detail in every element of the paintings. Then, compare them to his later masterpieces where only

FIGURE 67
Rembrandt van Rijn, **Self Portrait** *(detail)*
 National Gallery of Art, Washington, D.C.

the focal points, the dominant areas of interest are detailed, and even those areas are exciting juxtapositions of paint detail, quite impressionistic at close range.

The closure principle advises the wise artist to pass some forms in front of other forms, partially covering them. This not only adds depth to the study but allows the spectator to complete the covered forms in his imagination.

On your next photo outing, see how many snapshots you can take which feature a dominant direction and utilize this vital closure principle. Then, use those photos as reference for a creative composition in your next painting. Now, let's consider some other aspects of design.

Dominance of size

The rectangle you choose for your painting begins as a blank space. Each element you select to include in your composition will disturb that space in some directional movement. The space will in fact be broken up into several spaces by the inclusion of these elements. A horizon, for example, will slice the space of your rectangular painting and create two spaces. Each new space has a specific size. Unity demands dominance. Equal division of your canvas or panel space would not comply; there would be no dominant space size if the panel was divided in half. The wise artist avoids equalized distributions of space.

One space, one size should dominate your composition. The question of where to divide space immediately comes to mind. If not in half, then where?

Imagine a stand of pines in the background of your painting. Your photo reference might show the pines equally spaced (if they were planted by man), but Nature doesn't design this way; She prefers asymmetrical relationships. This calls for a rearrangement. Can you be specific? Can you prescribe a spatial proportion that would be beautiful? Is there a mathematical formula for the design of space most spectators would accept as most pleasing? Curiously, there is such a ratio. The ancient Greeks called it the Golden Mean.

FIGURE 68 FIGURE 69
The underpainting of antique weapons, old barrel and stuffed bobcat shows a corner of the artist's living room. Graphic analysis of spatial distribution is on the right.

FIGURE 70

The easiest way to divide a rectangle with a horizon and feature the Golden Mean is to divide the vertical boundaries into eight parts and place the horizon at three parts of eight. 3:5 is an extension of 1:1.618. Note that AB is to BC as BC is to the whole (AC). No other proportion so perfectly repeats itself. Student Nancy Blowers recomposes in compliance.

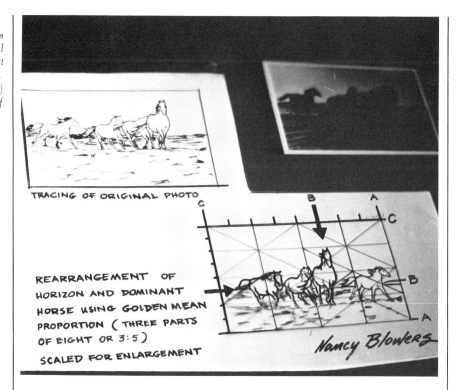

FIGURE 71

Of all the proportional ratios that it is possible to conceive, only one perfectly repeats itself. In Figure 70 we see a rectangular space that has been divided by a horizon. Imagine the top of the rectangle as 'A', the horizon as 'B', and the bottom of the rectangle as 'C'. If AB is considered to be a distance of 1, then BC is 1.618, or a little more than one and a half times AB. The relationship that makes this spatial division so unified is revealed when you consider that AB is to BC as BC is to AC. A perfect wrap. No other mathematical proportion repeats itself this way.

Now, I might have already lost some readers who find no excitement in mathematical relationships, but I suspect that even they will be astonished when I point to several natural forms and reveal their construction to be in accordance with this specific numerical ratio. Let's begin with your own finger. Assign a letter 'A' to your fingertip, 'B' to the first joint and 'C' to the next knuckle. BC is 1.618 times AB, and AC is 1.618 times BC!! The length of your hand is probably 1.618 times the width. The height of your head in relation to its width probably repeats the same ratio. I use the term *probably* because even nature designs with variation, but in natural design the Golden Mean proportion is always dominant.

FIGURE 72

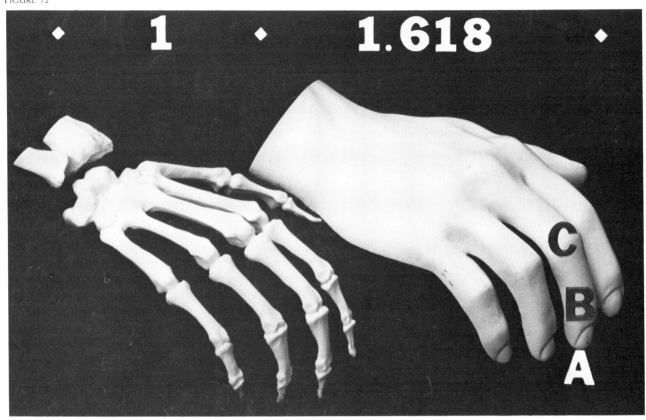

FIGURE 73

FIGURE 72
Your own finger reflects the Golden Mean, especially obvious when stripped to the bone. Fingertip bone length considered to be 1 relates to next bone length as 1.618. Same relationship continues with each bone toward the wrist. There, the hand meets the two volumes of the arm bone endings where we find the ulna volume 1 part to the radius volume of 1.618.

FIGURE 73
The spacing of veins on a maple leaf most frequently follow the natural order of the Golden Mean.

FIGURE 74
Industrial examples of the Golden Mean. How many others can you find in your own home?

FIGURE 75
Seashells reflecting the Golden Mean proportion.

FIGURE 74

FIGURE 75

Is it any wonder why the Greeks adopted the proportion for the construction of buildings like the Parthenon, why they used the ratio for the width of their building columns in relation to the spaces between them, why they employed the proportion in the design of their beautiful vases?

Wise artists employ the Golden Mean proportion in the design of their products because it mirrors the image of life. Since we are subliminally exposed to the proportion in so many elements of nature all through our lives, it is only logical we should be drawn to man's creative compositions that are organized with the same ratio. Leonardo may have been first among the great Masters of the Renaissance to divide his canvas space with diminutive repetitions of the Golden Mean. Classical academicians have been following his example for centuries, even abstract painters like Mondrian often employed it in his geometric designs.

It should be understood that dominance of size infers a comparison between the spatial distributions in your composition that results in one area being largest, but that area need not be the focal point or main element of emphasis.

The use of dominance with each of the designs that I am outlining is an effort toward the unification of a painting with abstract visual ascriptors which are not necessarily subservient to the mass of the central theme. In fact, my prescription for unity in creative composition can be extended with equally positive effect to the problem of spatial distribution faced by the abstract expressionist.

As an experiment, whether you favor that form of painting or not, create a non-representational

FIGURE 76
A graphic analysis of **The Last Fall**, *page 135*

composition utilizing dominance of direction, size, shape, texture, value and color and see what you can come up with. Your result might be an abstract expression fit for display in the Guggenheim. The best of modern painters employ this kind of academic thinking in their creative compositions. The only accidental stroke of a Franz Kline painting *might* be the first; from that point on, he is designing. You might ask, "Who is the better artist, the abstract expressionist who designs masterfully with the exclusion of representational forms, or the classical academician, who begins with an abstract division of space, value and color on his panel and then goes on to render with precision realistic forms to replace the abstract divisions?" In either case, visual unity is the primary goal and it is best achieved with *dominance*.

For practice, build yourself a "morgue" of photographs of landscape elements. Borrow a tree from one, a mountain from another, perhaps some clouds from still another, and build your own composition based on the Golden Mean. You will find that the most successful composition has a scientific basis.

Dominance of shape

While it appears the human mind has a compulsion to close forms that appear incomplete, it also seems to have a propensity for choosing harmony over discord. Both tendencies are the mark of a perfectionist, and perfectionism is the most common trait of the successful classical academician.

FIGURE 77
Still water reflections are natural repetitions of shape.

75

FIGURE 78

Harmony results from the use of dominance, repetition with variation and balance, all characteristics that are easily rendered with an abstract analysis of shape. For example, if one shape is repeated throughout the composition and it dominates in size and frequency, we may say that shape is dominant. The pose shown in my underpainting of Doris was no accidental posture. It is dominantly triangular. Propping her knee up into the viewing area, I was able to introduce another triangular shape and the position of her face and hair offers still two more triangular shapes.

Tension is a term used in paint-

FIGURE 79

FIGURE 80

ing to define a relationship established by two areas at opposite ends of the composition; if they are similar in some way — if they repeat with variation a common shape, then a tension is formed between the two, binding the composition with spatial unity. In the picture of Doris, her falling bangs relate to the climbing seaweed at the lower right of this sketch. Another tension is formed by repeating the cowl shape of her sweater in the parabolic sweep of the cloud in the sky.

Repetition and dominance of shape was employed again in the portrait of Grace. The dominant shape is the triangle. The space be-

tween her outstretched hand and her hip is a smaller repetition of the dominant triangle of her pose; the ratio of base length to the height of the apex is the same. Tucking my finger under the blanket, I was able to raise a section of it and introduce another triangle, and the profile of the head provided the opportunity for two more triangulars — the hair and the shape of her face.

The triangle is a useful composition device as it is a representation of stability and aspiration. In Figure 80 , the drape of the wolf parka rising to the peak of the cowboy hat establishes a dominantly triangular shape which is re-peated with variation in the unique shape of the Matterhorn at sunset. The figure divides the horizontal rectangle at the Golden Mean position and the peak of the mountain divides the space to the right of me in a similar manner. The mountain is split between its sunlit side and its shadowed side, offering another opportunity for me to repeat a dominant shape with variation.

Take your camera out again, and shoot a series of photos to demonstrate dominance of shape and repetition with variation. Use your photographic reference for an original composition of realistic elements. Use the sound design principle we have discussed.

FIGURE 78
Umber underpainting of Doris Jansson showing dominance of shape as explained in the text.

FIGURE 79
Portrait of Grace Mayberry showing dominance of shape.

FIGURE 80
The artist at the Matterhorn. A self-portrait in oils over an acrylic underpainting.

77

FIGURE 81

Closeup photo of textured surface of the Matterhorn in the author's self-portrait shows rough tactile variation which complements the dominantly smooth composition.

Dominance of texture

If the slick surface of a photographic type painting can be called unexciting and imitative, then the opposite technique, that of loading an entire painting with heavy texture achieved by palette knife applications of paint is equally insipid and contrived. In the academic prescription for creating significant art, there is such a thing as protecting the integrity of the medium. For instance, a stone carving should show some areas of rough unsculpted stone; a watercolor should look flowing, spontaneous and wet; an oil painting should be comprised of oil glazes and impasto applications of paint, etc. As in all beautiful designs, dominance is the keynote. Make your paintings dominantly rough, with some smooth glazed areas, or dominantly smooth, with some areas of heavy paint texture.

FIGURE 82

Texture is easily contrived with acrylics by adding modeling paste to the paint, as in this portrait by the author of Marge Hlinka propped on a rough barnacled beach boulder.

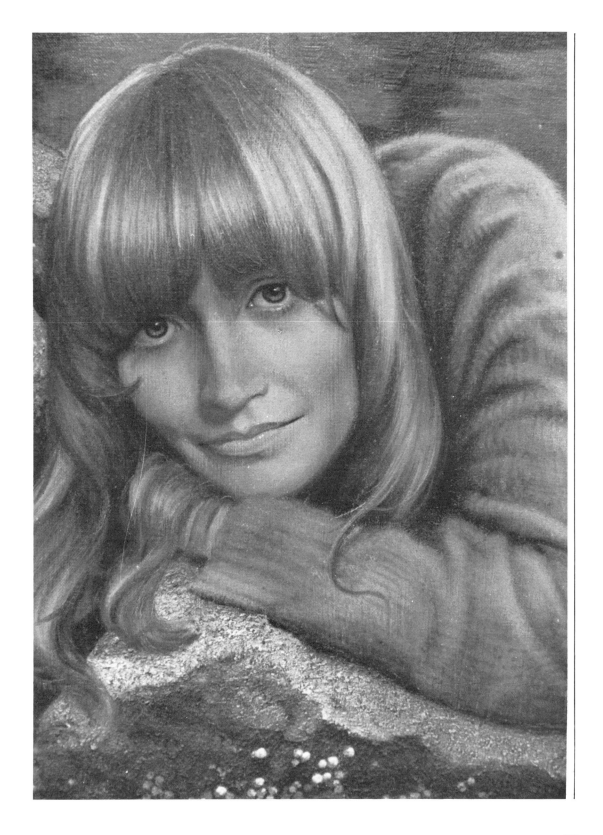

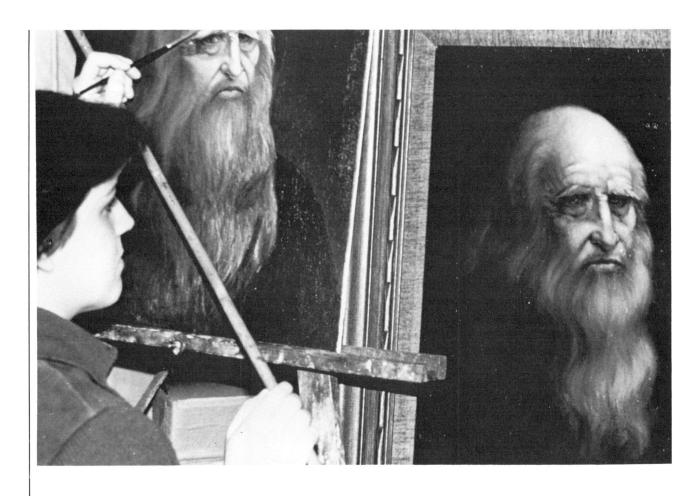

FIGURE 83

Fifteen-year-old student Nancy Blowers learned a great deal by copying the author's portrait of Leonardo da Vinci with the Classical Academic method.

This latter paint application, called *impasto*, may be comprised of just paint or of paint mixed with some foreign ingredient. Some of the Masters tried mixing marble dust, sand and crushed glass into their paints for sandy texture. Serious cracking usually followed. For oil paint, the safest foreign ingredient to create a sandy texture is Knox gelatin. Mix it right into your paint but use my medium as a binding agent. You can get Knox gelatin in your grocery store.

If you use nothing but paint for heavy texture, do it gradually, building successive layers rather than spreading one thick gob of paint. To do so you'll risk the cracking of the painting's surface in the future. To guard against cracking, add some softened beeswax to any oil paint which is applied more than a sixteenth of an inch thick. Dorland makes a good prepared wax for this purpose. Another alternative is to build your texture with acrylic modeling paste, if you begin with an acrylic overpainting.

A sandy texture may also be created by adding marble dust, sand or crushed glass to acrylic paint with no danger of cracking. Remember, acrylic underpaintings should be executed on a solid support such as gessoed masonite. A closeup of the mountain in Figure 81 shows the texture possible with

acrylic modeling paste. The color on the sunlit side of the Matterhorn is a burnt sienna glaze over the heavily textured acrylic underpainting. The painting is dominantly smooth with the small area of texture. In my small head study of Marge *en grisaille*, I mixed dirt with acrylic gesso to get the texture of the stone. The barnacles were sculpted with acrylic modeling paste.

As with all the design principles, nature is our teacher. We can see dominance of texture all around us. Smooth stones are found on the roughest sandy shores; dark rough-barked pines complement smooth leaves; the rough earth itself contrasts with the textureless sky.

For most of my portraits, I prefer the dominantly smooth with a small, rough area. Rembrandt often used this approach. If your taste leans in that direction, it would be to your advantage to copy a Rembrandt. There is much to be learned from such an exercise. Then, transfer the knowledge you gain from this experience to the creation of your own portrait.

Your turn. With your camera again, see how many shots you can take which feature a dominant texture. Use your photos as reference for a painting that is dominantly rough or dominantly smooth.

Experiment with Dorland's wax for heavy paint texture, with Knox gelatin for sandy or cement-like effects, with sand or crushed glass mixed with gesso for acrylic texture in underpaintings. Try to feel the excitement of variegated tactile surfaces, but always offer smooth variations as complements and allow one kind of texture to dominante the work.

The last two design elements, which should be employed with respect for the unity through dominance principle, are *value* and *color*. Each comprises a highly technical phase of the painting process and therefore deserve separate chapters. For now, simply be advised that a painting will be more visually pleasing if it has a *dominant value,* — dominantly dark, or dominantly light, or dominantly intermediate in key, plus a *dominant color* — one color that appears more than any other.

To conclude these thoughts on composition, I must caution you again to not be a slave to your photographic reference, particularly if the photo from which you paint is not your own. Moving a cloud, increasing the height of a mountain, shifting a tree can all be to your advantage if these modifications comply with good design principles.

Unity through dominance; dominance of direction, shape, size, texture, value and color. Experiment with the Golden Mean proportion as a basis for your composition. You will feel far more satisfaction in an original design than you ever could feel in the exercise of repeating exactly what you can see.

Painting is an intellectual experience. Are you capable of expanding your mind in this exciting endeavor? You are more than a camera. Any form of intellectual creativity is stimulating and is capable of making our lives more fulfilled. Let's strive to challenge the legacy of Plato. Artists deserve a prominent place in the republic.

IV | The Science of Value

The word *value* in art refers to a degree of lightness or darkness, *chiaroscuro,* in Italian. In order for an artist to be specific in his estimate of that degree, he should have a standard or scale against which he can compare the value under study. The simplest and most logical scale would be one that measures degrees of light in equidistant steps between black, the absence of color, and white.

In *The Romance of Leonardo da Vinci* (New York, Heritage Press, 1938, Book 6, *The Diary of Giovanni Boltraffio),*Merejkowski quotes his account of one of the earliest systems of mixing values:

"He *[Leonardo, his teacher]* has conceived the idea of a little spoon for the impeccably exact, mathematical measurement of the quantity of colours needed to depict the gradual transitions, barely perceptible to the eye, of light to shade, and of shade to light. If, for instance, one desires to get a given density of shade, one has but to take ten spoonfuls of black pigment; then to get the following degree, eleven; then twelve, thirteen, and so on."

The quantities of "black pigment" were, of course, mixed with white to produce gray value variations. Renaissance artists had to create their value variations with dry pigment. We can follow the same system today by mixing black into white paint, conveniently tubed. Ten graduated steps fit nicely into the decimal system. Thus, the first value can be considered ten percent light, while the ninth value would be ninety percent light.

You might compare values with the foundation of a building, the inner structure, without which the brick facade would fall, unsupported. That facade would relate to color, an embellishment, of secondary importance in the creation of a three-dimensional illusion on a two-dimensional surface. A building can stand quite well without the thin walls of its exterior, and a painting of three-dimensional forms can look very convincing painted in gray values with a limited super-imposition of color, or without color at all.

So it is that we accept black, white and gray photographs of people and scenes without reservation. For many years movies and television devoid of color successfully held our attention. We perceive three-dimensional form because of its relationship to light or the lack of it.

Apprentices to the Old Masters studied the effects of light dispersion and the rendering of values for years before being allowed to consider color. For centuries, classical academies throughout Europe designed their curriculum in the same manner.

First came the problems of drawing with accuracy. The graph helped in the learning process. The Master's gradual elimination of the strings led to his student's proficiency in drawing "free hand." It was a good teaching device. Next, came the study of values. Division of the scale of grays between black and white into equidistant steps gave the Master a constant standard for value identification and meaningful criticism of the work by their students. The Master could be specific. Instead of extending a criticism like "too dark" or "too light" he would say "two values too

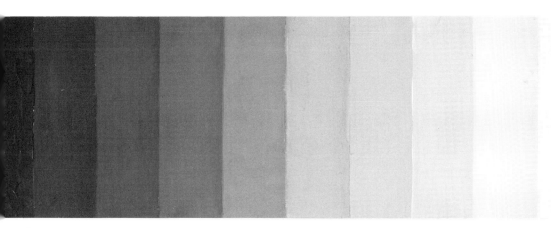

FIGURE 84
Chart of equidistant gray values between black, zero (the absence of light), and white, ten, one hundred percent light.

dark" or "lighten the shadow on that arm one and a half values." The scale of values provides a vocabulary for three-dimensional identification and reproduction.

Because an accurate value rendition is essential to the representation of three-dimensional form, the Old Masters of the early Renaissance began their paintings with an *underpainting* in chiaroscuro. Some underpaintings were executed in brown and some in gray-green tones called *verdaccio*. Gray underpaintings are called *grisailles*, a derivative of the French word gris meaning gray.

In his revealing "Discourse Eight" Sir Joshua Reynolds tells us, "An artist in his first essay of imitating nature, would make the whole mass of one colour, as the oldest painters did." Once this

monochromatic value study was completed, colors were glazed over it or were applied opaque after first conditioning them to the corresponding values of the chiaroscuro. This system was practiced by academicians up to the Impressionistic era, when painters became more fascinated with the visual stimulation of color than with the illusion of three-dimensional form. About the same time much of the academic craft was replaced by a more expressionistic approach to painting where color is often mixed on the canvas, rather than pre-mixed on the palette.

Non-objective "art" featuring color without form and innovation for the sake of innovation was soon to follow. In the process much of importance in the method of paint-

ing was lost. The primary effort of this book is to retrieve the lost craft and defend the ancient system as a significant and logical approach to communicative painting worthy of perpetuation.

To facilitate the process of chiaroscuro identification and reproduction I devised a Controlled Palette for my students. Essentially, it consists of nine gray strips representing percentages of light from black, zero, to white, ten.

This is covered by a piece of plexiglass — used instead of glass because it is more suitable for mailing. (You may order one by writing to Covino Palette, Box 420, Waitsfield, Vermont 05673, but you could make one for yourself at less expense.) To create your own palette, just paint the strips on a piece of cardboard and tape glass

FIGURE 85
The Controlled Palette, inspired by the late Frank Reilly, improvised and fashioned by Frank Covino.

or plastic to the top of it. This system is sure to accelerate your learning process.

If the surface of your Controlled Palette is plastic, rub olive oil onto it before mixing paint. This will help prevent scratching of the plastic with your palette knife and it will keep the values clear. My students have the choice of mixing nine graduated gray tones on the Controlled Palette for painting *en grisaille*, preferred for still life renderings, skyscapes, seascapes, etc., or nine gray-green tones to stimulate the verdaccio of the Old Masters, preferred for

the painting of flesh. Later on, they are encouraged to try the warmer rub-out approach favored by the Venetians, and also used by Florentines such as da Vinci and Raphael. Fortunately for us, we can see the process in unfinished works like da Vinci's *St. Jerome* (1483) in the Vatican Gallery, Rome, and in his *Adoration of the Kings* (1481-2) at the Uffizi in Florence.

When I am convinced that the student's perception of values is acute and his capacity for rendering those values with oils is adequate, I recommend the gray or gray-green approach for under-

painting in acrylics. Since acrylics dry rapidly, it is conceivable you might underpaint with them in the morning and begin an oil color superimposition the same day.

For underpainting with grays in oils you're advised to create the graduated values by mixing Mars black with flake white. (Flake white was the primary white used by the old Masters. In fact, they often used it over their sized panels and canvases as a ground in place of gesso. It is still considered to be the safest white to use for underpainting because of its low oil content.) Mars or ivory black mixed

FIGURE 86
Comparing photo values to the Controlled Palette.

FIGURE 87 *The Controlled Palette in use.*

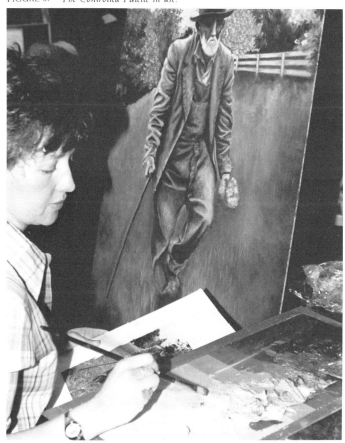

with white will produce a blue-gray, of no consequence if the underpainting is to be covered with color, but, should the coolness disturb you, you can neutralize the grays by adding raw umber to value one, raw sienna to value four, and yellow ochre to value six, intermixing these colors to neutralize the gray values that are in between. Gray values from seven to nine may be neutralized by mixing white with yellow ochre to lighten it for the corresponding values. These golden yellows will kill the blueness of grays mixed from black and white.

The Grumbacher company markets four neutral oil paint grays in tubes which are convenient, but the numbers on the tubes bear no relationship to the values they hold. Grumbacher gray number one is a *ninth* value, number two is a *seventh* value, number three is a *fifth* value, and their number four is a *second* value. Intermixture of these grays will produce the values that are in between while black mixed with Grumbacher gray number four will produce a *first* value.

Liquitex also markets neutral grays tubed from value three to value eight. Liquitex also makes neutral gray values in acrylics which correspond to the numbers on the Controlled Palette, but I advise my advanced students to mix their own; to use gesso as the white for tinting Mars black, since a gesso-based underpainting is safer as a ground for oil color superimposition than the acrylic values made from white which are glossier. The acrylic gray values from Liquitex are excellent for weakening the intensity of acrylic colors, should you wish to complete your painting exclusively in acrylics.

It is imperative that no oil be used in your underpainting colors. Use an evaporating medium (lean) like the resin turpentine. Other oils, (fat) like linseed, dry in a jelly-like film from the top down. What may be dry to the touch may still be quite wet underneath. If a less oily color is placed on top of a color into which a "fat" oil has been mixed, the paint on top may dry first. When the paint beneath finally dries it contracts, causing cracks and fissures in the leaner superimposed surface. Try a test yourself. On a scrap piece of can-vas, paint a swatch of ivory black about a sixteenth of an inch thick. When it's dry to the touch (in a few days) paint a swatch of flake white on top of it. Within a few months, the flake white surface will be fraught with cracks, particularly if you added linseed oil to the ivory black swatch! It is always wise to paint "fat over lean."

As a craftsman, you should know which colors are lean enough to consider as acceptable paints for underpainting and which colors should never be considered because of their high oil content. Here is a list you should copy and tape inside of your oil paint box.

COVINO ACADEMY OF ART

Tape this to your paint box.

Colors of Low Oil Absorption (best underpainting colors)

1	MG White	4	Chromium Oxide Green
2	Venetian Red	5	Zinc White
3	Flake White or Chremnitz White	6	Zinc Yellow (Lemon)

Medium Oil Absorption (not to be used over any color in the following two categories)

1	Yellow Ochre	5	French Ultramarine Blue
2	Cadmium Yellow Light	6	Titanium White
3	Cadmium Red Light	7	Cadmium Green
4	Thalo Yellow Green		

High Oil Absorption (good overpainting colors)

1	Cadmium Orange	6	Cerulean Blue
2	Winsor Orange	7	Raw Sienna
3	Alizarin Crimson	8	Mars Black
4	Ivory Black	9	Burnt Sienna
5	Raw Umber	10	Burnt Umber

Very High Oil Absorption (best overpainting colors)

1	Cobalt Blue	3	Lampblack (bluer)
2	Cobalt Violet (dark)	4	Viridian Green

Any color in the medium, high or very high oil absorption category must be mixed with at least 50 percent of a color in the low oil absorption category if it is to be used in an underpainting, unless it is to be superimposed with a color equal in high oil absorption.

Turpentine is the safest medium to use for underpainting, as it evaporates. Use my formula as a medium for overpainting and glazing: 5 parts Damar varnish; 5 parts rectified turpentine; 3 parts stand oil; 1 part Venice turpentine.

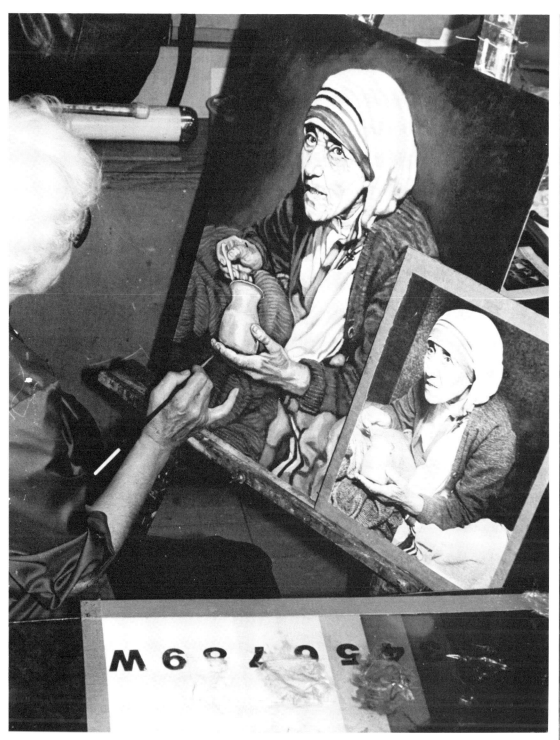

Figure 88
Verdaccio values mixed and staggered by student Jeraine Reinwald.

Cracking is not the only problem. There is a painting at the Prado by Velasquez of a rider on a horse. The horse has six legs. Apparently the Master had second thoughts about the positioning, so he just painted over the incorrectly painted legs of his underpainting with a lighter background value and then repainted the legs more accurately. What he didn't realize was that oil paint dries with some translucency over the years. Dark tones underlying lighter ones will appear through the surface. The Old Masters from Italy called this *pentimente*, a colloquialism meaning "a sin of the past catching up with you..."

My students are encouraged to eliminate all dark tones of the underpainting that require correction. I often scratch off dark tones that have dried with an X-acto knife if they need correction. If you try this method, don't scratch too deeply or you might chip off some of your gesso ground. Should this happen, you *must* replace the gesso before continuing to paint with oils. A small drop on the point of your brush stick will fill small holes. When dry (in a matter of ten minutes) sand the newly gessoed area lightly with an emory board and repaint it. Incidentally, a sharp X-acto knife is great for scratching the final touches on hair (Fig. 90); no painted stroke can be as fine as a scratched stroke.

In his later years Rembrandt executed his underpainting *en grisaille* but preferred a loose application of paint, blocking in his major value difference but not fussing with detail, which he preferred to leave until the color

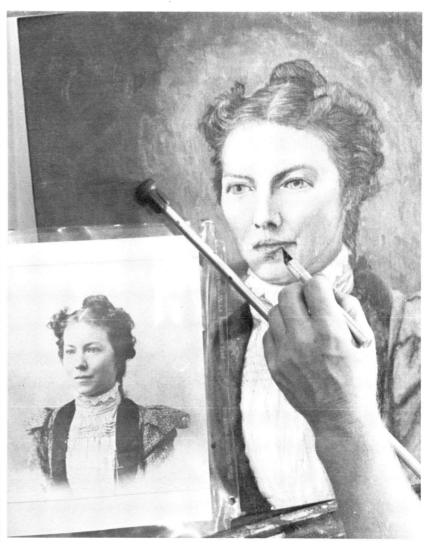

FIGURE 89
Incorrect dark values must be scratched out before painting over them, to avoid pentimente. Student George Moffett complies.

stage. X-ray studies by the National Gallery in Washington, D.C., have confirmed this approach. The younger Rembrandt was probably a lot tighter in his underpainting renditions, more in the tradition of the Florentine Masters. Artists such as David and Ingres also preferred a tight, carefully detailed grisaille over a carefully modeled sketch. Their color superimposition was a cumulative succession of glazes and thin opaque paint applications, with little paint texture visible. Towards the end of his life, Rembrandt worked with such heavy impasto one art critic commented, "You can pick up a Rembrandt portrait by the nose!"

FIGURE 90

Should you visit the Metropolitan Museum of Art in New York City; try to see The *Odalisque* by Ingres *en grisaille.* The painting in gray values, has a slightly warm tint on one of the background draperies, probably his first colored glaze over this incomplete painting. Look closely at the other paintings by Ingres and also those by his teacher, David. See if you can detect signs of the grisaille beneath the color. You'll find these grays particularly apparent in the half-tone areas, those parts of form that separate illuminated sections from shadowed parts.

Many French Masters preferred gray underpaintings. Consider this excerpt from the Journal, July 10, 1847 by Eugene Delacroix: "Painted the Magdalen in the Entombment. Must remember the simple effect of the head. It was laid in with a very dull, gray tone." Here's another quote by Jean Baptiste Camille Corot from his essay "Color and Tones": "That which I look for while I paint is the form, the harmony, the value of the tones. Color comes afterwards." To some painters, tone and value mean the same thing. Corot was apparently referring to the *specific* darkness or lightness of a "tone."

The cool gray half-tone areas are one of the major differences between good portraits by the Masters of the past and superficial likenesses seen in the works of many lesser portrait painters,

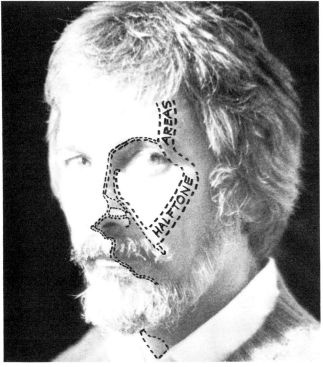

FIGURE 91

Graphic illustration of halftone areas. They are the spaces which separate light from dark. Model is student Bill Weathered.

FIGURE 92
Jean-Auguste Ingres, **L'Odalisque en Grisaille**
The Metropolitan Museum of Art, New York

where the flesh looks wooden or like leather. These latter aberrations often do not include the half-tone areas, probably because they are not apparent when working "from life." If you were merely tinting a statue with flesh tone, it would not be necessary to include half-tones since the form is already three-dimensional, but your job as a portrait painter is to create an illusion of depth on a two-dimensional surface. To do so, you need to wield some technical tricks, *schemata* passed on to us by the Old Masters, and the most notable of these for realistic looking flesh is the half-tone separation between light and dark. Some French portraits show these half-tone areas as quite gray, probably because of their gray underpaintings. The flesh Rubens painted, however, shows half-tone areas that are gray-green, suggestive of *verdaccio* underpaintings. He was probably influenced by Italian Masters whose work he analyzed while painting in Rome.

Verdaccio is an Italian phrase meaning "greenish first." It is a form of underpainting with values that are gray-green. To mix a set, begin darkening chromium oxide green with Mars black until it becomes a second value (your mixture should be darker than a third value and lighter than a first value). Compare the mixture to the second value strip on your Controlled Palette. This is your *base color.* Lighten the base color with flake white to create values three through nine. Mix your colors with a small triangular blade palette knife so as not to spread the mixture all over your palette. More Mars black added to the base color will produce a

first value to complete the set.

If you stagger your paint piles it will be easy to cover each pile with a small separate square of Saran Wrap. At the end of your painting session cover the entire palette with another sheet of Saran Wrap. Then slip the entire palette into a plastic garbage bag and seal it. When you begin to paint, *uncover only the first three values;* leave the Saran Wrap square covers over the other values until you are certain that you have painted all the first,

second and third values of your underpainting. Then, and only then, should you uncover the next three values.

When values one through six have been painted, uncover the last three values and apply as needed. This method is an important discipline, practiced in the *verdaccio* and repeated again during the color superimposition. It is necessary to prevent you from mixing high value colors with low value colors, the road to instant *mud.*

FIGURE 93

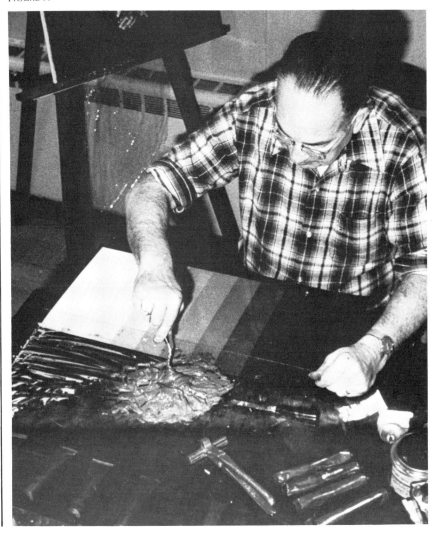

FIGURE 94

One of my painting professors at Pratt Institute used to walk around the room with his hands behind his back and criticize our paintings in progress with a favorite phrase, "That area is too muddy. Clean it up!" Now, he was certainly right in his critical analysis, but he never said what "muddy" meant, and he never told us *how* to "Clean it up!" No student would dare ask, from fear of sounding like a dolt amid a room full of potential Rembrandts. By trial and error, I soon realized that "muddy" color was caused by mixing a high value color with a contrasting color of low value. With students of portraiture this usually happens when they have to paint a third value shadowed part of the face next to an illuminated part that reaches up into the seventh, eighth or ninth value. The secret, of course, is to move from dark to light in gradual increments, i.e., from a three, to a four, to a five, to a six, seven, etc., even if the steps are narrow applications of paint.

I often tell my students, "You have a nine value palette. If you're wise, you'll paint with *eighteen* values." This means moving from dark to light in *half* steps rather than full. With sharp edges the initial application of close values will look like a "number painting," but what a joy it is to blend with a soft flat sable when all of these values are present. Tubing of separate values is recommended.

While the application of close values is a critical consideration in color, it is best practiced in the underpainting. Even though it is certainly possible to blend a gray of the third value with a gray of the seventh value and produce a subtle transition, it is advisable to move from dark to light gradually, value by value, before blending, to condition your mind for the color application that is ahead. A flat sable brush dragged lightly down the line that separates two values from each other should blend the transition quite well if the brush is wide enough to overlap one value with its left side and another with its right. If you have difficulty with this method try the zig zag approach shown in Figure 95.

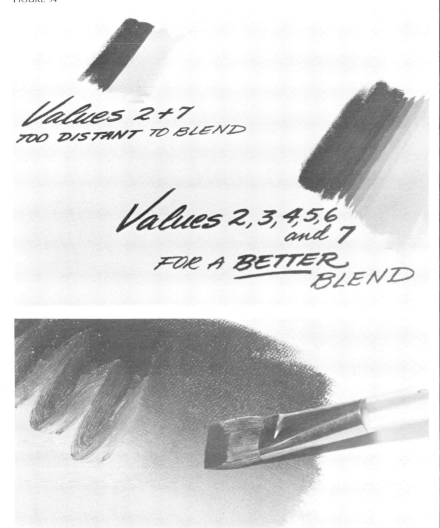

FIGURE 95

For your early training in the portrayal of values it is advisable to work from black and white photographs. Just compare the values of the photo to the values of your Controlled Palette, but be forewarned that photographs can lie, particularly if they are not in color. A fifth value red will look like a second value gray in a typical "black and white" photograph unless a warm filter has been used by the photographer. The ideal solution for the painter who works from photographs is to have both a color print and a black and white print for reference. Paint the underpainting from the latter and refer to the color print when the color is superimposed.

For portraits I prefer to match my colors to the live subject rather than to a color photo, as most color prints are not accurate reproductions of the model's complexion. They are influenced by the studio lights, by the type of film, by the time of the development and by the age of the print. Most complexions appear realistic if they have been painted over verdaccio underpaintings, particularly if some of the gray-green is allowed to show through the flesh color in the half-tone areas (the areas that separate light from dark).

Your first *grisaille* (a monochrome painting using two or three gray values) should be based on a simple landscape color photograph. Make obvious comparisons first, like the dark shadows of a tree trunk with the low values on your Controlled Palette. Surely you can see that the dark shadow is not a ninth value, not an eighth or seventh; it is darker than a six or a five. Now, be careful. Is it darker than a four? Is it lighter than a first value? By process of elimination you'll find the correct value. If you're wrong, you'll probably be only one or two values off, easily correctible when you're underpainting.

Accurate recognition of values is a cumulative learning process. Just as the musician must play hundreds of scales on his piano before he can recognize a specific note, so you must perform hours of value analysis before you will be able to identify and mix values with precision. For some sutdents it "comes easy," but most of you will

FIGURE 96

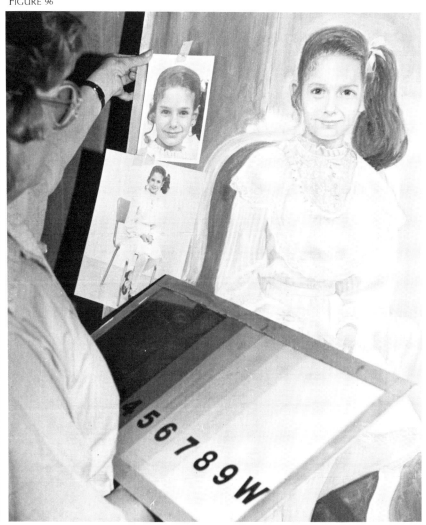

FIGURE 96
Compare the values of your photo to the value strips of the Controlled Palette. By process of elimination you'll arrive at the correct value. Student Mary Hovhannissian compares.

FIGURE 97 →
Airtight jelly jars can keep your acrylic values wet and useable for years.

FIGURE 97

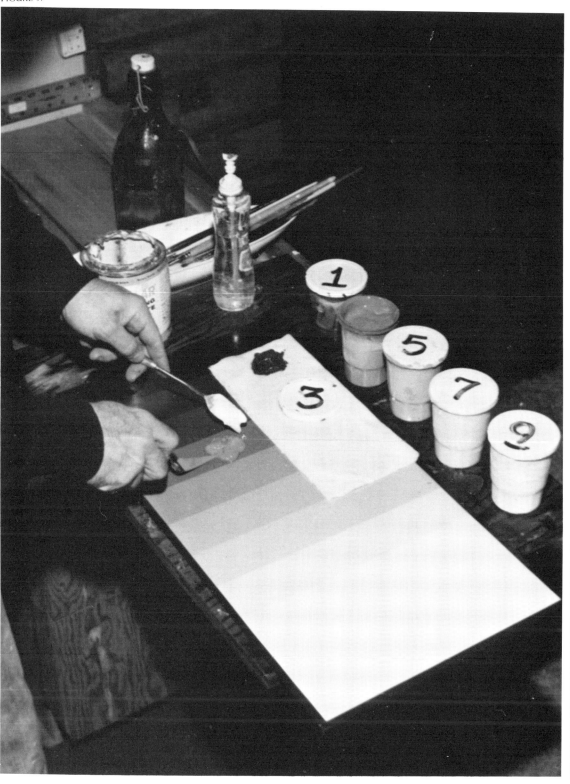

need hours of practice, and that doesn't apply only to mixing and painting. First you must practice *seeing*.

Students have asked how I manage to maintain my *precision of vision* when I don't paint every day. The answer lies in the last word of the italicized phrase. Classical academic painting begins with *vision*, the capacity to see things accurately, things that many people look at all their lives but don't really *see*. I am constantly painting, because I am constantly analyzing the things in my field of vision.

Students have confided that my course has not only taught them how to paint. It has taught them how to see, and in doing so, has intensified their sense of sight, and life has become more meaningful, more fascinating and certainly more beautiful!

Advanced students who want to try underpainting in acrylics are advised to begin with gesso as a base. For gray values, just darken the gesso with Mars black. An abbreviated palette of five values, one, three, five, seven and nine is enough because of the rapid drying characteristic of acrylics. For *verdaccio* tones, mix equal amounts of Hooker's green and Mars black and use that to darken the gesso. Jar the paint mixtures in airtight containers. Jelly jars are practical for large amounts, but 35mm film containers are excellent for small quantities.

You may add some *retarding medium* and *gel* to the colors that you store, but don't liquify the paint; keep it creamy. When you're ready to paint, spread about two feet of Saran Wrap on a table allowing one foot to drape over the edge. Soak a roll of three or four sheets of paper toweling with water and place it on the Saran Wrap; this will be your palette. On a separate palette or dish, spoon out a small amount of first value paint from your storage container. Mix a little gel into this first value, then place it on the wet paper toweling. The extra addition of gel will allow this first value to flow better.

To the other values add some modeling paste until the paint is of the consistency you want it to be. Then put them onto the wet paper toweling. I like to increase the modeling paste admixture with each higher value, in keeping with the academic dictum: "The higher the value, the thicker the paint...." A spray bottle of water should be kept close by (an old Windex bottle works well) and each paint pile should be sprayed lightly about every ten minutes. This system should keep your paints wet for the entire painting session.

When you're through for the day, lift the foot of Saran Wrap that was hanging over the edge of the table and fold it across your wet paper towel palette. With the other foot of Saran Wrap beneath the wet palette it should be sufficiently airtight for storage in your refrigerator until your next painting session.

The painting procedure for acrylics is no different than painting with oils; paint the dark values first, and gradually work up to the lighter ones. The softening of edges is more difficult in acrylics. You have to either be fast, or do a third value area with a fifth value in juxtaposition, allow both to dry, then dip a round bristle brush into a fourth value, wipe off most of the paint until the brush hairs are just barely stained, and scrub the edge between the third and fifth values with this until the edge disappears.

The rub-out method of da Vinci was executed with an umber tone, probably a paint called *bistre*. Contemporary umber colors are high in oil absorption and unsafe to use as underpainting colors unless they are mixed with fifty percent of one of the colors listed as most acceptable for underpainting. For example, raw umber and lemon or zinc yellow would be O.K. in equal amounts. Venetian red and Mars black in equal amounts would also provide a suitable brown tone for underpainting with the rub-out system. As always, turpentine is the only safe medium to use for thinning colors selected for underpainting. The rub-out system requires great facility, however, as the paint dries quickly.

For novice students who require more time, linseed oil may be used, but be careful to wait three or four weeks before superimposing color over any underpaint that has been thinned with linseed oil. This will help to guard against cracking. Students who paint for posterity should use no oil at all. Turpentine is the safest medium for underpainting with the rub-out method.

Begin the rub-out by rubbing your canvas or gessoed Masonite panel with a rag that has been dipped into turpentine or linseed oil. It should be damp, but not dripping wet. Then cover the entire surface with your underpainting color mixture until it is as dark as the predominant dark value of your subject.

If you are working from a

graphed photograph, score your guide lines by ruling into this wet underpainting value with a pencil eraser. If you tap a pair of ¾ inch brad nails into a wooden ruler every five inches and allow the points of the nails to be exposed about a quarter of an inch on the other side, you can use this for ruling with less paint smearing. You may sketch with a small pointed sable brush and raw umber or scratch in with the point of a palette knife.

Once roughly sketched, begin your value study by rubbing out the illuminated areas with a dry lint-free cloth. Do this by stretching the cloth over you forefinger. Work fast. Your paint is drying! The harder you press with your rag, the lighter the value will become; gentle taps of the rag will produce middle values. For values darker than the original tone with which you covered the entire canvas, add raw umber, but keep the dark areas stained with very thin paint applications; no texture should be developed in the dark areas or the light areas with this form of underpainting. Detailed areas of dark may be painted in with sable brushes, and very light value areas may be lightened with a turpentine soaked rag.

FIGURE 98

FIGURE 99

FIGURE 98

Oiling down the panel. New students may use lin-seed oil for their first attempts, as the paint will re-main wet longer.

FIGURE 99

Preparing a wooden ruler for use on a wet canvas. Allow the brad nails to protrude about a quarter of an inch.

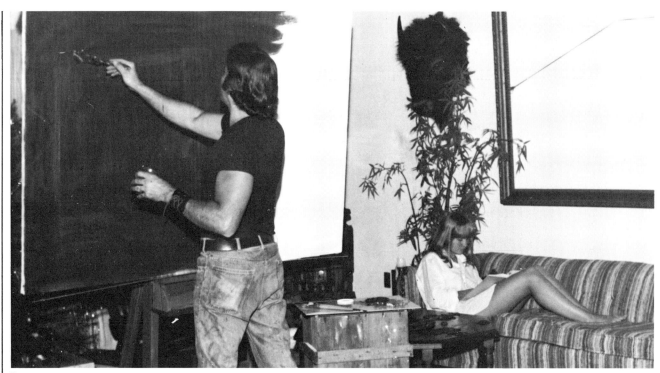

FIGURE 101
The author tones his canvas with a third value to represent the dominant value of his underpainting.

FIGURE 102
Sketching with a rag stretched over forefinger. Students usually sketch into the dark tone with a palette knife or a pencil eraser.

FIGURE 103
One hour into the sitting, my model fell asleep. I covered her with a blanket and continued, working from a photograph.

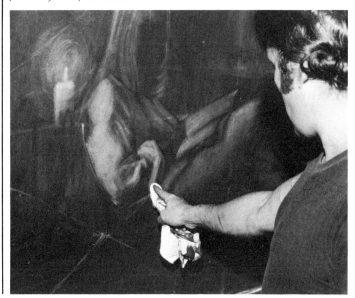

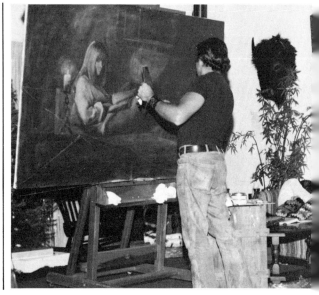

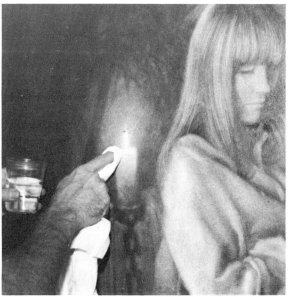

FIGURE 104
Only turpentine was used as a thinner. I had to dip into some occasionally to wipe down to the white of the canvas.

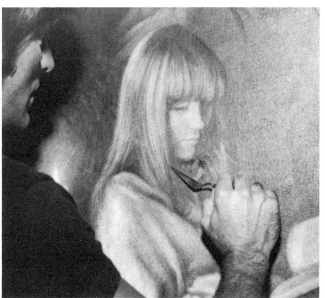

FIGURE 105
The palette knife was used for scratching fine hair strokes.

FIGURE 106
The descriptive values of surrounding objects were kept close to maintain a low key, and to provide closure opportunities for those who view the painting.

FIGURE 107
I try to carry the painting as far as I can with a rag, and only pick up a defining brush at the end.

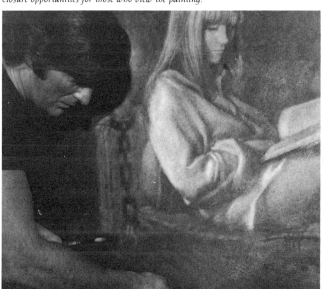

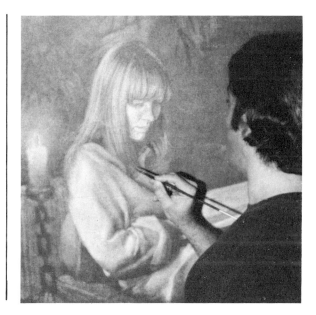

Some rub-out work may be done the next day, but most of your painting will probably be dry. If it is, you can still lighten some areas with sandpaper, or by scratching with your palette knife. Figures 108 and 109 show the completion of this underpainting.

Often there is such charm to these rub-out underpaintings that many students are content to go no farther with the superimposition of

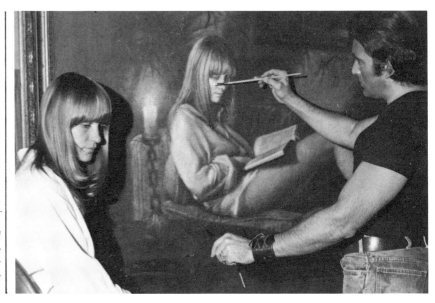

FIGURE 108

I slipped the painting into its frame, because I wanted to paint the frame into the upper right part of the composition, in an effort to push the dominantly horizontal direction. A few final touches, and the rub-out underpainting is ready for color.

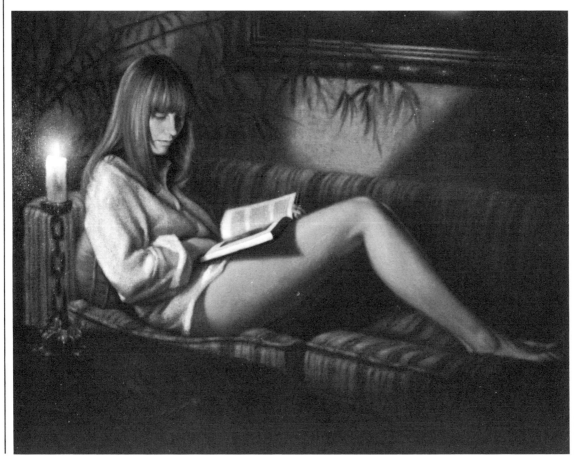

FIGURE 109
Candlelight Portrait
Finished painting.

color. For that matter, all under-paintings have a certain quality that frequently makes the student reluctant to add color. The study of values is indeed a satisfying science, since values are the foundation of form. Another even more beautiful dimension can be added with color as form's embellishment. We'll get to that soon.

We have learned there are different approaches to underpainting, but the primary motivation for each is the same: to separate the problems of form from those of color. To quote the eminent British portraitist and scholar of aesthetics, Sir Joshua Reynolds, "The artist will solve the mystery of imitation sooner by first considering light and dark independently of color, and making himself acquainted with it in its whole extent."

DOMINANCE OF VALUE

Since value is one of the artist's tools for creative composition, it follows that a dominant value in a composition will add to its unity. Thus, a painting will be more successful in terms of good design if it is dominantly dark, dominantly light or dominantly intermediate in key. Remember that *dominance* presupposes *dominated*; for a painting to be dominantly dark it must include some areas of other values.

The question arises, "How much less?" and "How small an area?" The answer is dependent upon the mood you wish to create and its relationship to a system of value keys and harmonic relationships.

We need a basic vocabulary

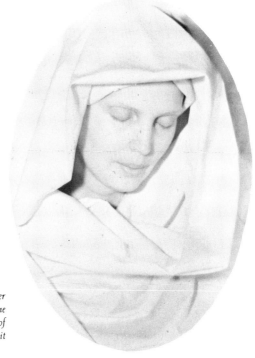

FIGURE 110
Only a zone eight adjustment of the meter reading and longer development enabled me to produce this high minor key photo of my wife Patty. Her fair eyelashes made it possible.

for the description of the variables. Without getting too technical, let's call a dominantly light painting *high* in key, a dominantly dark painting *low* in key and a painting of dominantly middle values *intermediate* in key. For the harmonic relationships, call close values *minor* and values that are distant from each other on our scale of nine values, *major*, to qualify the spread. Thus, a painting that is mostly light, but with one shot of dark somewhere can be classified as of a *high major* key. If *all* the values of a high key painting are close, seven, eight, nine and white, it would be of a *high minor* key. A painting of values four, five and six would be one of an *intermediate minor* key. Add a spot of value nine or one to that same painting and it would become

an *intermediate major* key. An all dark value painting would be of a *low minor* key, because of the major difference between the light value and the darkest value.

Now we have a vocabulary. Let's take a look at some photographs that illustrate these various keys and harmonic relationships and consider them as subjects for paintings.

Fig. 110 shows a high minor key. How do you feel about it? Does it suggest delicacy, fragility, femininity? It suggests these things to me, but a feminist might argue the point. How about the high major key of Fig. 111? Do you feel any different about it? Does the addition of the dark value make the form more "real," less ethereal more assertive?

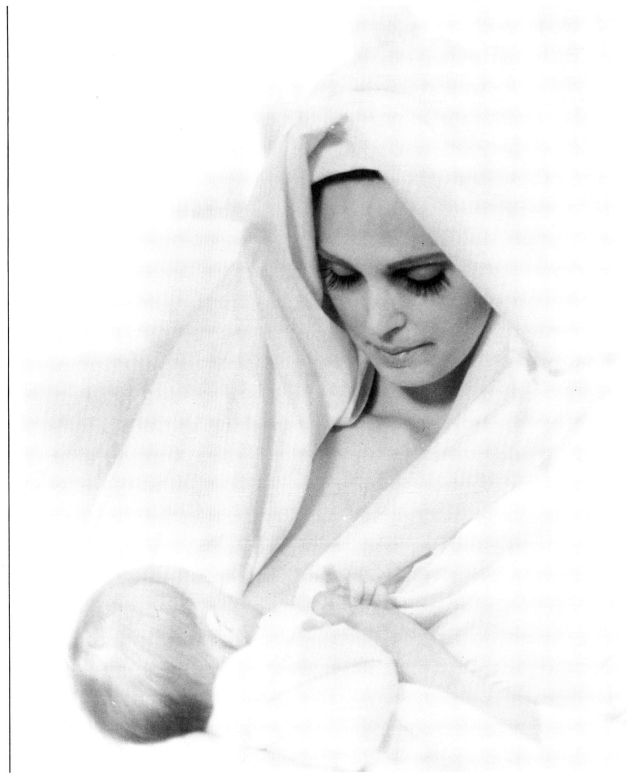

FIGURE 111

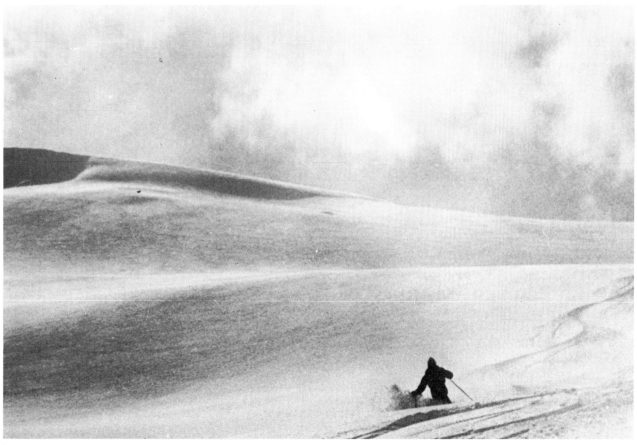

FIGURE 112

← FIGURE 111
The addition of a small area of dark value makes this portrait of Patty and our son, Mark, a **high major key.**

FIGURE 112
The dreamy **intermediate minor key** *catches the author at a magic moment.*

How do you react to the intermediate minor key shown in Fig. 112? This is the key popular with muralists who want to protect the integrity of the wall on which they paint. It lacks depth, is kind of dreamy, reminiscent of morning mist. The intermediate major key maintains the dreamy atmosphere but creates a focal point with its addition of a major value difference.

Our aesthetic choices are closely related to our own personality needs. How do you feel about the low minor key in Fig. 113? Solemn, morose, depressing, mysterious — how would you classify it? Rembrandt loved the low major key seen in Fig. 115, on page 105. That's my world, too, but it might not be yours. Different people are moved by different value keys in different ways. Your job is to motivate them in *some* way. Clever painters are usually armchair psychologists.

We all know that beauty is in the eye of the beholder, and none of us would be comfortable for long if someone tried to alter our standards. This is why it is futile to teach a definition of *good* art. What may be good to me might be entirely bad to another. As a teacher, I can only point to the art that has survived centuries of conflicting critical systems and suggest we study the constant factors present in such art.

It is up to you to do what you will with this information. Trends come and go, but classical principles remain. An awareness of value keys and harmonic relationships gives you more options in your depiction of realistic form. You needn't be a slave to your photographic reference. Use it to

FIGURE 113
The depressing **low minor** *key might be just the right key for an evening landscape or a somber portrait.*

FIGURE 114
A dark or light note added to an intermediate minor key changes it to an **intermediate major.**

FIGURE 115 →
Rembrandt's favorite **low major** *key is also favored by the author.*

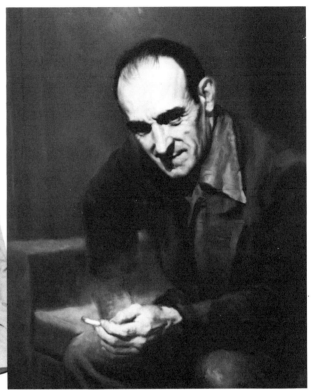

FIGURE 116
The snapshot with the busy background lacks a dominant value, but it inspired the low major keyed portrait of my dad. Which do you feel has more emotional impact?

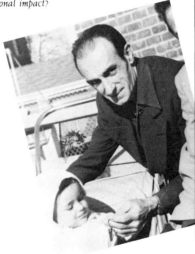

spark your imagination, but don't deprive yourself of the opportunity to adjust the key of the photo to suit a particular mood and elicit a specific response from your audience.

Value keys and harmonic relationships are important considerations in the learning process of your craft. Each variation will affect the spectator of your work differently. If you can move him, stimulate him, get him to respond in *any* manner, then you can consider your artwork to be a success. Try a painting that illustrates each of the variations I have shown. It is possible to paint many variations from the same photographic reference.

For example, let's assume that you have taken a clear photograph of someone, but the middle value background establishes an intermediate major key; the typical "snapshot." Boring. Use the photo for reference, but try darkening the background, keeping the strongest light concentration on the forehead. You could turn the commonplace photo into a more artistic low major portrait! Or, lighten the background and limit all face values to the high range, except for the eyes, and you'll have an exciting high major portrait!

Try it with a landscape, a still life, a seascape. Change the values of what you see to establish a particular value key (dominant value) and a particular harmonic relationship (minor or major). The real excitement of painting comes *after* you have learned to paint things as they appear. Rendering those same things in varied value keys and harmonic relationships is a giant step toward significant creative composition, because each of your original conceptions will reflect nature in their employment of the vital principle of *unity through dominance*. Your imitation of nature will then be more than an effort toward verisimilitude; the camera is quite capable of that. It will be an imitation of her manner of creativity, and who can be a better teacher than nature? Leonardo advised:

"The painter will produce pictures of little merit if he takes the works of others as his standard, but if he will apply himself to learn from the objects of nature he will produe good results..."

V | The Science of Color

No poem can be created without words. No symphony can be composed without notes and chord identification. And we cannot discuss color without a specific vocabulary. Yet, such is the practice in many art classrooms.

About half a century ago the art world was jarred by the theories of Albert Munsell, who ascribed to color a set of terms for identification, discussion and reproduction. Without such terminology, the art student is in for a lot of difficulty. If art can be taught at all, it must have meaningful language.

In the fashion industry you've heard of a color called baby blue. The very same color might be called powder blue in the auto industry, ice blue among house painters and light blue in a box of crayons. What is needed is an identifying word or symbol that will mean the same to everyone in *any* industry; a color name that will refer to only one particular color. Now there is such a name. Munsell called it the *hue*, and he narrowed the field down to ten basic hues from which any color can be mixed. What a relief to know that it is not necessary for a student to buy the four hundred-odd tubes of paint on the shelf at the local art store to portray the things he sees!

The ten basic hues come from the color of light itself as it is seen when beamed through a prism; they are the colors of the rainbow. Since purple appears at one end of the ribbon and red-purple appears at the other, it seems logical to relate the two ends in juxtaposition and establish a color wheel. The Munsell color wheel is logical and scientific. It includes secondary colors between the ten basic hues and each movement away from a basic hue is numbered in graduated steps. This makes color identification even more specific. In my classroom, we have found it practical to limit the number of hues to the basic ten in the early stages of the learning process. Color, though, has more to it than *hue*, which only refers to its name.

Each of the ten basic hues is *light* or *dark*, but lightness and darkness are terms that are too broad. A scientific approach demands specificity. How light? How dark? Relating color to a scale of gray values such as those which appear on our Controlled Palette, Munsell ascribed a number to each hue which indicated precisely *how* dark or how light it is. Thus the hue yellow (cadmium yellow light by commercial name) is as light as a ninth value gray, ninety percent light, so it received the number nine to describe its precise value. Purple-blue (ultramarine blue) is as dark coming from the tube as a first value gray, ten percent light, so it was assigned the number one to indicate its specific value. This system closely conformed to that of Leonardo and was probably borrowed from him.

The "commercial" name is the name that appears on the paint tube. Munsell did not indicate these, so I have prepared a chart relating the most common commercial names to the ten basic hues.

Hue and value are only two parts of the tri-structured anatomy of color as defined by Munsell. Color also has *chroma*, another word for *intensity* or brilliance. While value refers to the specific

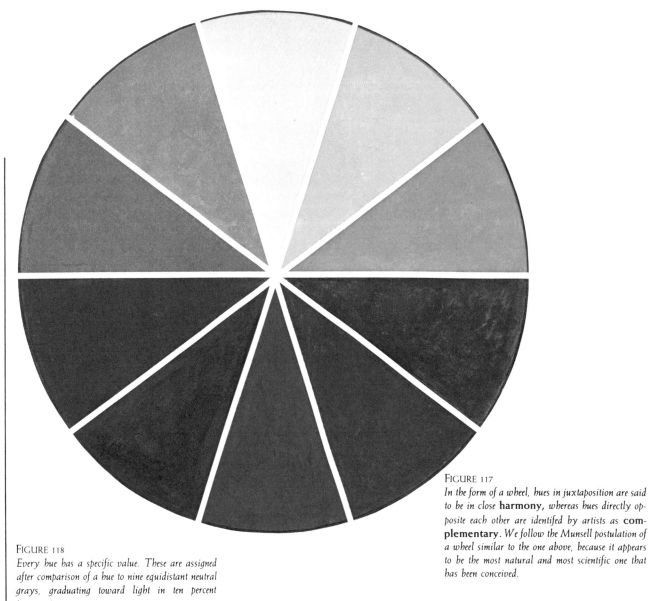

FIGURE 117
*In the form of a wheel, hues in juxtaposition are said to be in close **harmony**, whereas hues directly opposite each other are identifed by artists as **complementary**. We follow the Munsell postulation of a wheel similar to the one above, because it appears to be the most natural and most scientific one that has been conceived.*

FIGURE 118
Every hue has a specific value. These are assigned after comparison of a hue to nine equidistant neutral grays, graduating toward light in ten percent increments.

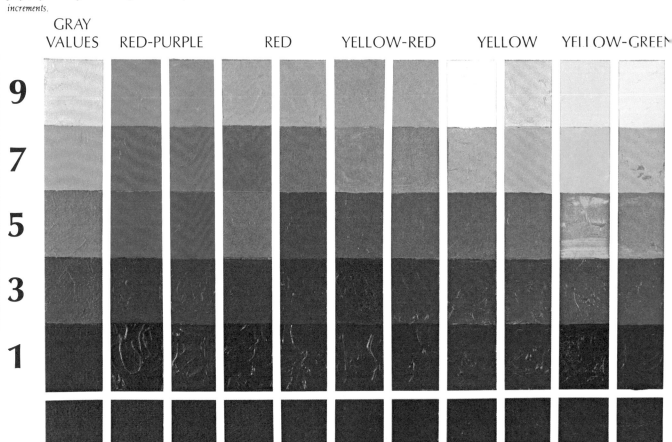

GRAY VALUES	RED-PURPLE		RED		YELLOW-RED		YELLOW		YELLOW-GREEN

9

7

5

3

1

darkness or lightness of a hue, chroma refers to its specific brightness or dullness. Here again Munsell assigned a numerical symbol for precise description, with the number one being one step away from neutral gray. Some hues are naturally brighter than others due to their chemical structure. Red, for example, is 10 steps away from neutral gray in its purest form (vermilion or cadmium red light), while blue is only 6 steps away from neutral gray at its brightest intensity.

The difference between brightness or dullness and lightness or darkness may be confusing to the reader who has had no experience with a scientific approach to color. Think of it this way: If I wore a bright yellow scarf that is as light in value as a ninth value gray, and I walked away from you, the brilliance of the yellow would appear less intense (duller) as the distance between us became greater. The scarf would not appear less yellow; the hue would remain the same. If the light in the distance was intense, the scarf might even retain its ninth value status on a scale between black (zero, the absence of light) and white (ten, or one hundred percent light). The only difference is that the yellow appears less bright as it recedes; it becomes duller.

GREEN BLUE-GREEN BLUE BLUE-PURPLE PURPLE

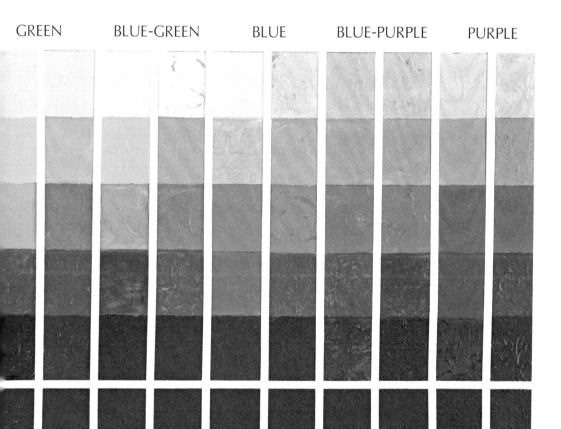

The basic rule of aerial perspective advises us that close objects appear brighter than distant objects. An orange in your hand will appear brighter that the same orange in the hand of someone fifty feet away from you.

Don't be intimidated by the structural analysis. Some students run away from the suggestion that science might be at the core of anything artistic. Psychologists now tell us that this is because of the split characteristic of our brain. The right side is purportedly our creative, artistic one; the left side is one reacting more to numbers and scientific data. This may be so, but the fact of the two sides residing in juxtaposition, each a contributor to an integrated whole, suggests that it is natural to combine both forces for the most significant creative effort. The creative individual whose whole life is one of free expression with no respect for science, is probably as limited and as uninspiring as the ivory tower scientist or engineer who can't appreciate work that has no function other than aesthetic stimulation.

It was discovered by classical academicians of the early Renaissance that the gray-green tones of *verdaccio* underpaintings weakened the intensity of high chroma colors that were superimposed, if those bright hues were applied thinly, glazed or partially rubbed off. From this developed the practice of mixing

FIGURE 119
A high value purple-blue can weaken the intensity of a high value yellow, but some of the yellowness is sacrificed.

neutral gray pigment with colored pigment to dull its brilliance before application in those areas of the painting which required duller tones. The value of the additive gray pigment was, of course, matched to the value of the color. For example, a high value (light) color such as yellow would require a high value neutral gray to weaken its intensity (make it duller), whereas a dark color like purple-blue would require a low value (dark gray) to dull it.

The neutrality of the gray was imperative in order to protect the autonomy of the color. If a greenish or a bluish gray was added to a yellow it would weaken its brilliance, but it would also change the color to a yellow-green. Blue-gray pigment made from charred bone and lead were adulterated with earthen brown pigments to make them neutral. They were then separated into ten vessels, each representing a percentage of light between black and white. The neutral gray pigments were then added to colors that matched their values, carefully spooned in specific quantities to conform to the demands of aerial perspective, and then turned into a paint by mulling them with linseed, poppy or nut oil. All colors in this classical academic approach were pre-mixed before superimposition over the underpainting.

While the pre-mixing of colors

was a carry-over from the earlier days of painting al fresco, it sensibly separated the problems of form (drawing and chiaroscuro) from the problems of color. To paint directly in color with no underpainting was considered an aberration of the craft, as foolish as constructing the facade of a building before raising its foundation. Leonardo scoffed at paintings which emphasized color with disregard for form, deprecating such art as being of value "only to their manufacturers." In that comment, found in one of his notebooks, some scholars have deduced that a form of abstract or expressionistic painting might have been going on five hundred years ago. If so, where are these paintings today? Why have they not survived the centuries of art criticism that the works of the Old Masters have sustained?

The pre-mixed or Controlled Palette enjoyed centuries of respect and use by classical academicians, before painters lost patience for the preparative phase of the craft. The practice of grinding pigment with oil was obviated by commercial tubing of colors.

There seems to be no evidence of tubed neutral gray pigments prior to the 20th century, though I suspect that they did exist. The *grisaille* underpaintings of French classical academicians replaced the Italian *verdaccio* preparations and it

FIGURE 120
Neutral gray value nine, added to yellow value nine will weaken the chroma (intensity) of the yellow without changing the hue!

is doubtful that these careful studies in gray variations were not executed with prepared gray paints. Some painters prefer to weaken the intensity of color by mixing into it a complementary color (opposite on the color wheel) but the values of the two colors have to be consistent or the result may be muddy.

It is certainly possible to dull a yellow by adding to it a purple-blue, but purple-blue is dark and yellow is light. White must first be added to the purple-blue until it becomes as light in value as the yellow; the resultant mixture can then be used to dull the yellow without reducing its value. It does, however, also reduce its yellowness, turning it a bit green. Compare the result to the reduction of yellow brilliance caused by adding a neutral gray that matches the value of the yellow. The latter, a Renaissance method, is still the most valid one.

Science, in my opinion, is the basis of art. This was also the opinion of Leonardo da Vinci, Titian, Velasquez, Rubens, Ingres, Reynolds and of many of the masters trained in the classical tradition. The hue, value and intensity designations as identified by Munsell give color a vocabulary so exacting that you and I could have a meaningful conversation about color problems, even if our discussion must be through the mail!

Constructing The Ten Hue Color Charts with Variations of Value and Intensity

Step One cut three 18 x 24 inch canvas boards in half to produce six boards 12 x 18 inches.

Step Two Paint each of these canvas boards about a fifth value gray with latex deck paint, which you can get at your local hardware store. Paint both sides to prevent warping.

Step Three Tape each board with ½-inch masking tape as shown in Figure 121. There should be ten gray squares across and seven gray squares down.

Step Four On your Controlled Palette, mix nine neutral gray piles of paint matching the gray strips of the palette as closely as you can. You can make your own Controlled Palette by painting nine strips on the back of a piece of glass or plexiglass with the acrylic gray values manufactured by the Liquitex Company, darkening their lowest gray values with acrylic Mars black to get the first three values. For some reason they don't manufacture these values in acrylics.

NOTE: Mixing gray values from black and white alone will not produce *neutral* grays; the paint will be a cool blue-gray. For neutrality, the blueness must be eliminated. This is easily done by mixing into the blue-gray raw umber for value one, raw umber plus raw sienna for values two and three, raw sienna for value four, raw sienna plus yellow ochre for value five, yellow ochre for value six, and continue to add yellow ochre to kill the blueness of gray values seven through nine. Should your budget allow it, you can eliminate this step of

FIGURE 121

neutralizing blue-gray values by buying neutral grays in tubes already mixed.

A visit to my classroom by Binney and Smith color scientist, Nat Jacobson, and our subsequent conversations, preceded that company's production of a line of neutral grays numbered three through eight under the trade name *Liquitex*. Moreover, the same company is now producing a line of colors labeled with hue, value and intensity designations that conform quite well with Munsell's theories.

With the Liquitex Modular Colors produced by Permanent Pigments, Jacobson has devised a concise course in color identification based upon the Munsell system, using the same gray value scale employed in this book.

The charts that I am about to outline can be created with colors which are manufactured by all oil paint companies. Recommended also is the Liquitex Color Map and

Mixing Guide, available from Binney and Smith, Inc. This guide is similar to the charts you are about to construct, except that many of the color variations you will soon mix are available from Liquitex pre-mixed and clearly illustrated on their "Map."

Red-Purple

Step One Beneath the nine neutral grays that you have mixed on your Controlled Palette you will mix nine values of *red-purple* (RP), first of the ten hues on the color circuit. Most brands produce this hue under the commercial name *alizarin crimson*. It is usually as dark as a first value, although it appears as a second value in some brands. Place a pile of it beneath its corresponding gray value on your Controlled Palette and make lighter values of this hue by adding white to alizarin crimson.

In the Liquitex Modular series, the hue red-purple is available as

manganese violet for value one (RP-1) as *deep magenta* for RP-3, *medium magenta* for RP-5 and as *light magenta* for a seventh value red-purple (RP-7). Thus, the Liquitex line provides four different values of red-purple which you could approximate by adding white to alizarin crimson, but your resultant mixtures would never match the pure intensity of the Liquitex tubed variations.

Step Two You should now have a complete set of gray values on your Controlled Palette (from one through nine) above a line of red-purple values mixed in the same gradations. We'll call this row of color *maximum intensity* or maximum *chroma*. Next, with your small triangular paint mixing knife, mix two parts of color with one part of the gray value above it to produce what we'll call *medium intensity*. Do this beneath each of the red-purple values until the line is complete.

Step Three Finally, mix a row of *weak intensity* red-purple values by mixing two parts of gray with one part of color on each value strip of your Controlled Palette.

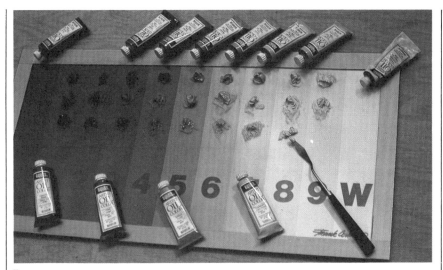

FIGURE 122

FIGURE 123

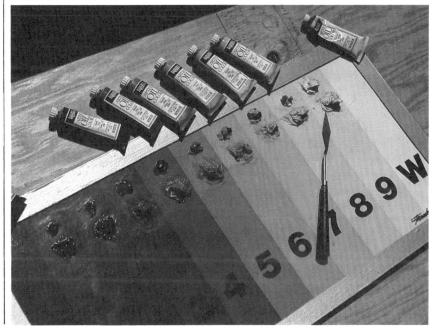

FIGURE 121
You may go over the tape, as it will be peeled, but try to not get paint under the tape. Student Carol Hallac uses her finger.

FIGURE 122
The blue family. That's cobalt blue at the first value, cerulean blue at the third, Liquitex's modular brilliant blue for value five and their permanent light blue for value seven.

FIGURE 123
Nine red-purple values at **maximum** *intensity. This is as bright as red-purple can get at each respective value.*

Step Four. When you have mixed three different intensities for each of the nine red-purple values (and make sure that the differences are obvious), transfer each pile of paint to your taped canvasboard in the same order. Most students use their finger to apply the paint but any other device may be used as long as the paint completely covers the square intended to house it and as long as the application is opaque enough to completely hide the gray latex. You may, of course, overlap the masking tape with your paint application, as the tapes will be removed when all the exposed squares have been painted, leaving sharp-edged square of color.

Become familiar with the color vocabulary or your chart will have little meaning. Each color that you see in nature can be described by a specific hue, value and intensity, but all three parts must be identified. Your color charts will provide the standards for such identification, and you're advised to refer to them in the planning of any painting. The three variations of chroma (intensity) maximum, medium and weak should be sufficient as a starter. Surely, you may be confronted with the need for a hue that is weaker than weak, — one that may require more than two-thirds of a neutral gray in its mixture. Simply comply by adding more gray. Just be certain to keep the value consistent.

Let's now continue the completion of your first chart. There should be three rows of empty squares on your chart. Rid your Controlled Palette of all the red-purple mixtures, but leave the neutral gray values which we'll continue to use.

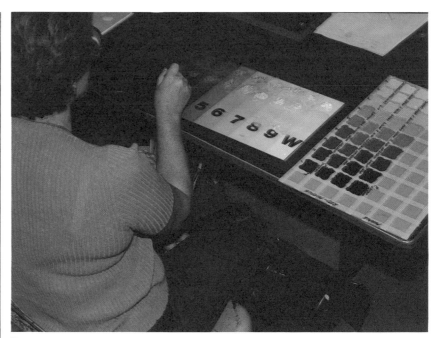

FIGURE 124
Mixing a medium intensity purple at the fifth value.

Purple

Step One The best purple available at the first value is called *dioxazine purple* by Liquitex. In other brands you may use cobalt violet, but be sure that it is as dark as a first value in the tube. Some brands of cobalt violet are as high as value three and this color is not purple at all, but rather is a variation of red-purple similar to Liquitex deep magenta. You may lighten dioxazine purple or cobalt violet by adding white to produce values two through nine. Place these maximum intensity values beneath the gray value piles on your Controlled Palette (Figure 125). To obviate the hassle of mixing eight other values, Liquitex provides three of them at a vibrant intensity: *prism violet* may be used for value three, *brilliant purple* is value five and *permanent light violet* is a good seventh value purple. Lighten the value of all colors above their purest hue with white, preferably titanium.

Step Two Mix a row of medium intensity purple values beneath the maximum intensity row. The formula is the same as we used for red-purple, two-thirds color plus one-third gray, with the value of each consistent.

Step Three Mix the weak intensity row. Two-thirds gray plus one-third color for each of the nine values.

Step Four Transfer your purple set to your first color chart (beneath the red-purple set), peel off the masking tape and allow it to dry. You have finished your first color chart.

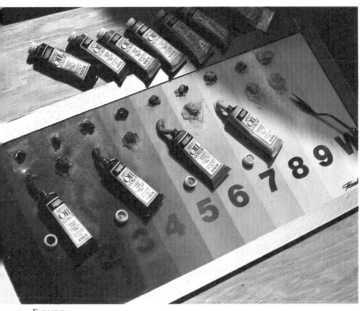

FIGURE 125
New Liquitex modular colors offer brilliant intensity and take the hassle out of mixing.

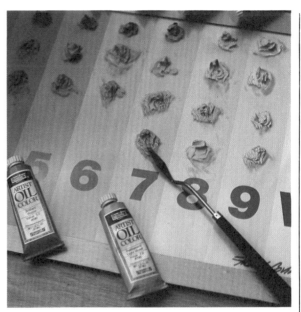

FIGURE 126
Two-thirds gray for weak intensity.

Purple-Blue

Step One Here we have a color that has the same commercial name in all brands, *ultramarine blue*. It is also as dark as a first value gray, so the procedure for lightening its value is similar if you choose to mix the eight lighter values. Simply add white. Liquitex offers *brilliant blue-purple* for value three and *light blue-violet* for value six, if you want maximum intensity. That company suggests their cobalt blue as a second value purple-blue, but in most other brands pure cobalt blue is made from the same ingredients as cerulean blue (pure oxides of cobalt plus aluminum) so I prefer not to include it in the purple-blue family. You may notice also that Liquitex calls this hue blue-purple while I prefer purple-blue.

Step Two Mix the medium intensity row with two-thirds color plus one-third gray.

Step Three Mix the weak intensity row by inverting the formula to two-thirds gray plus one-third color.

Step Four Apply your gray value mixtures and your purple-blue mixtures to your second color chart and clean your palette in preparation for the mixing of the next hue.

Blue

Step One The purest blue in all brands is *cerulean blue*, which comes in the tube sometimes at a third value and sometimes at a fourth, depending upon the brand. It maybe lightened with white for the higher values, or you might want to try Liquitex's *brilliant blue* for value five and *permanent light blue* for value seven, intermixing for the middle values and lightening permanent light blue with white for values eight and nine. In most brands, cobalt blue may be used as a darkener if it comes from the tube as dark as value one. *Prussian blue* may also be used to darken if it is a first value in the tube. Your maximum intensity set should look like Figure 122.

Step Two Weaken the intensity of each maximum chroma value by mixing it with one-third gray for medium intensity.

Step Three For weak intensity the formula remains: mix two-thirds gray with one-third color and keep the values consistent.

Step Four Apply your color to the bottom of the second color chart and peel the tapes.

115

Blue-Green

Step One Viridian (value one) in most brands makes a good set of blue-green values when mixed with white. My students have used it exclusively for many years before the advent of the modular system. To maintain a brilliant turquoise chroma, though, you had better consider Liquitex's *turquoise green* for value five and their *bright aqua green* for value six. Intermix these for the middle and low values and add white to bright aqua green for values seven through nine. These values should be mixed beneath a row of neutral gray values, one through nine, on your Controlled Palette as before. They are your maximum intensity blue-greens.

Step Two De-intensify the blue-green values by mixing them with one-third gray for medium intensity. Be sure to keep the value of the color the same as the value of the gray to which it is added. This row of color should be mixed beneath the maximum intensity row on your Controlled Palette.

Step Three Modify the blue-green values to weak intensity by mixing each with two-thirds gray. When this third color row is completed apply all of the mixtures to your next color chart.

FIGURE 127

The beautiful blue greens. That's viridian at value one, Liquitex's turquoise green at value five and their bright aqua green at value six.

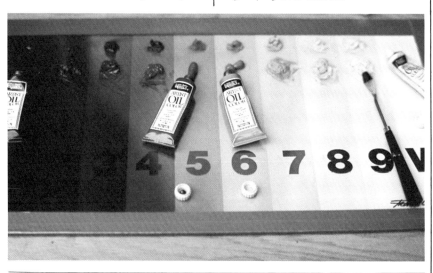

FIGURE 128

Peel tapes as soon as your chart is complete, or they'll be difficult to remove later.

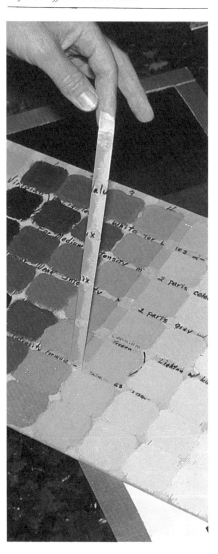

Green

Step One Liquitex's *brilliant green* is the purest maximum intensity green. Close behind is Winsor-Newton's cadmium green (painfully expensive) and Shiva's cadmium green. All three come in the tube at a fifth value. For a darkener, try a mixture of viridian (three parts) plus raw umber (one part) as value one. Also available, to maintain maximum chroma at the lower levels, is *permanent green deep* (value three) and *emerald green* (value four) by Liquitex. They also produce a sixth value green labeled *light emerald green*, which may then be lightened with white for values seven, eight and nine.

Step Two Mix the medium intensity row as before, two-thirds color plus one-third gray.

Step Three Mix the weak intensity row as before, two-thirds gray plus one-third color for each of the nine values.

Step Four Apply the mixtures to the bottom of your third color chart and peel off your tapes.

Yellow-Green

Step One Begin the mixture for this fourth chart as before, with the equidistant gray values at the top. I know of only two brands which produce a good maximum intensity yellow-green. Grumbacher's *thalo yellow-green* and Liquitex's *brilliant yellow-green*. Both are high at value eight. Prior to the modular line, my students used a mixture of raw umber (one part) plus viridian (two parts) for a first value darkening agent. Use it if you can't afford the darkeners offered by Liquitex: *vivid lime green* for value seven, *chromium oxide green* for value four, *green earth hue* for value three and *permanent sap green* for value one. Since the purest yellow-green is a high eighth value, add white to it to produce value nine. This first row of yellow-green values comprises the maximum intensity set.

Step Two Mix the next row of yellow-green values at medium intensity (two-thirds color plus one-third gray). Be sure to make your paint piles of sufficient quantity to cover the squares on your color chart.

Step Three Mix the final row of weak intensity yellow-greens as before, one-third color plus two-thirds gray.

Step Four Apply your mixtures to the top of the fourth color chart.

Yellow

Step One Cadmium yellow light is the purest yellow, value nine in the tube. Darken it with a lower value yellow, like yellow ochre at value six (most brands) or the Liquitex Naples yellow at value seven. I prefer raw sienna as a value four darkener and raw umber as a first value yellow. Some brands produce raw sienna as a third value and if raw umber is a second value, darken

it with ivory black. Some companies offer Van Dyke brown, a rich first value yellow, but authorities like Ralph Mayer have warned us about its impermanence and susceptibility to cracking. Liquitex offers a good fifth value yellow labeled Mars yellow. They also list their cadmium yellow medium as an eighth value, but I think it's too orange to be included in the pure hue family of yellow.

Mix your nine piles of maximum intensity yellows beneath your neutral gray values on your Controlled Palette as before.

Step Two For the medium intensity row, mix two-thirds of each color value with one-third of each neutral gray value.

Step Three Two-thirds gray plus one-third color for each value will produce a weak intensity variation for the bottom row of yellows.

Step Four Transfer all mixtures to the bottom of your fourth color chart.

Yellow-Red

Step One Consistent with the Munsell charts, we adopt the label yellow-red as a replacement for what most people think of as orange. In its purest state, the commercial name is cadmium orange, value seven. Lighten this with white for values eight and nine. I advise burnt sienna as a darkener of cadmium orange. In some brands burnt sienna is produced as value three, but it is often tubed as value two and a half. Compare your color to the gray value strip on your Controlled Palette. The darkest

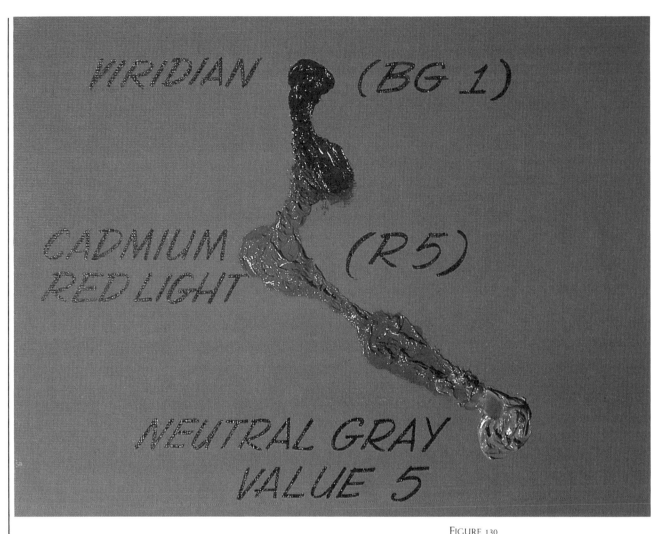

VIRIDIAN *(BG 1)*

CADMIUM RED LIGHT *(R5)*

NEUTRAL GRAY VALUE 5

FIGURE 130

The intensity of red weakened with a neutral gray that is the same value.

value yellow-red is burnt umber (value one). Use it to darken burnt sienna for value two. This should give you nine maximum intensity yellow-reds, mixed beneath a set of neutral grays.

Step Two For the medium intensity row, mix two-thirds of each color value with one-third of each gray value.

Step Three For weak intensity, mix two-thirds gray with one-third color and complete your third row of color.

Step Four Apply this yellow-red set to the top of your last color chart. You're almost finished!

Red

Step One Cadmium vermilion red light is the purest, with cadmium red light close behind. Both come tubed at a fifth value. Lighten with white to produce values six through nine. Liquitex's offering for a pure eighth value red is *light portrait pink*. For darkness, Liquitex markets a brilliant red at the fourth value, which they call *Chinese red*, and a good third value red labeled *deep brilliant red*, but there is no first value red that does not lean toward purple, so I've advised my students to mix equal amounts of burnt umber and alizarin crimson for the lowest (1) value red.

Step Two Create medium intensity reds as before, by mixing two-thirds of each color value with one-third of its corresponding gray value.

Step Three The final weak inten-

sity row is mixed as before, with one-third color plus two-thirds gray of matching value.

Step Four Apply all mixtures to the bottom of your last color chart. That was a heroic effort. Peel your tapes and set aside the chart for drying.

Step Five When all five charts have been completed and they are thoroughly dry, tape a piece of clear acetate over each one. On the acetate write with a black marking pen the names of each of the colors which came tubed plus a brief statement of how you arrived at the medium and weak intensity variations. Some students poke two holes through the clear strip of their color charts and run a ribbon through them to attach all five charts together in a book form. This makes the charts more portable for on site color analysis.

With twenty-seven variations of each of ten hues, you should be able to find most natural colors on one of your charts, *and now you'll know exactly how to mix them!* Figs. 131, 132 and 133 show a few students referring to their color charts in the mixing and application of a Controlled Palette. Compare this controlled approach to the dip-dab-and-scumble school so common in most art schools.

Take your color charts with you on your next hike. Find the colors of nature by comparison. Identify them specifically by hue, value and intensity. Make the same kind of comparison with color photos and reproductions that attract your aesthetic attention. Take notes, make rough sketches indicating the various hue, value and intensity designations. Then

FIGURE 131
Student Bill Lombardi discovered the classical academic approach to painting late in life.

FIGURE 132
Nine purple-blue values beneath nine neutral grays, with Liquitex modular colors used at the third and sixth values. I prefer ultramarine blue for a first value.

FIGURE 133
Student Betty Bossert works with a good controlled flesh palette.

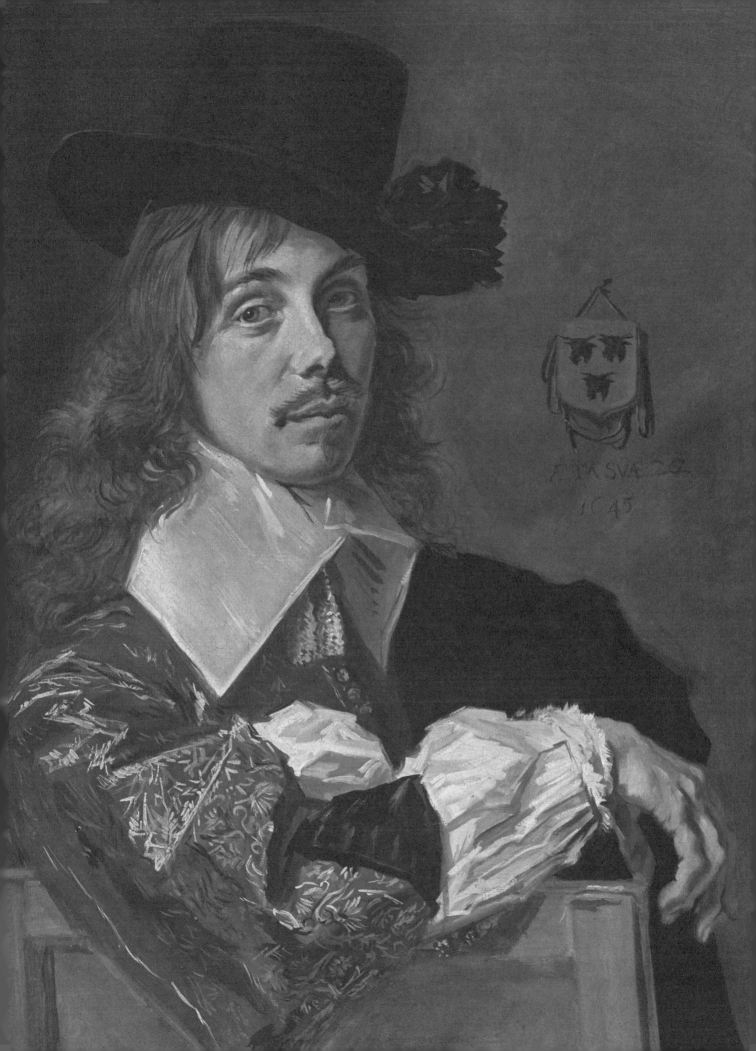

paint your painting.

While the construction of the charts may have been a nuisance and on the surface may appear restricting, you will soon recognize its value and realize a new freedom that you may never have expected to attain. The classical academic painter works out his problems carefully, preparing his palette before touching paint to his canvas. Every nuance of color change is mixed in a separate pile on his Controlled Palette. The actual paint application over a monochromatic underpainting moves rather fast. Mixing time frequently takes as long or longer than the time required for paint application.

When the classical academician applies his stroke to the canvas or panel it is usually correct. There is seldom need for intermixing or superimposition (discounting the special effects created by glazes and scumbles). The flashy positive strokes of a Frans Hals, I believe, came from a brush dipped into a Controlled Palette; they are too clean and unadulterated, like those of John Singer Sargent. Even a tighter rendering like the work of classical academician Ingres or David, his teacher, demands a carefully prepared palette to avoid "muddy" color.

Granted, there is a certain charm to the broken color effects of a more romantic type painter who solves his color problems on his canvas, leaving evidence of his struggle. I would never refer to such a painting as having had a wrong approach. It is simply a *different* approach, the method that is practiced in most art classrooms.

Most paperback book cover illustrators today work with a Controlled Palette, applying their premixed colors over a carefully rendered underpainting. Many of them owe their education to a fine teacher, Frank Reilly, who taught for years at the Art Students League in New York City.

The instructions I have provided refer to the basic ten hue circuit. For most amateurs, that should be sufficient. Serious artists are insatiable when it comes to data that might develop a more acute perception, however. For them, we must consider at least the color variations which fall in between the ten basic hues, i.e., yellow-yellow green, green-yellow green, green-blue green, blue-blue green, blue-purple blue, purple-purple blue, purple-red purple, red-red purple, red-yellow red, and yellow-yellow red. The clear sky, for example, does not appear to be blue or purple blue at low elevations; it appears as blue-purple blue. Flesh color frequently is not yellow-red, but is often red-yellow red. Please refer to the inter-value hue chart at the end of this chapter.

Imitating Nature's Creative Formula
(see chart on page 134)

Now, let's consider color sense — that capacity some people have for arranging color in a way that most spectators find pleasing. Basically, I reject the theory of intuition as the only prerequisite for this ability. The approach defined here will serve anyone well because it is based upon *natural* selection.

Nature's balance is consistent, so the wise artist emulates and tries to repeat a similar balance in his composition. When I think of balance, a scale or teeterboard immediately comes to mind. A heavy person on one end can only be balanced by an equally heavy person on the other end, but then neither of the weights would be *dominant.* If one person was much heavier than the other, the lighter one would have to move to a greater distance from the fulcrum to effect a balance. With color we can allow one hue to dominate (cover the most area) and make that dominance more interesting by juxtaposing other closely related hues in close harmony (repetition with variation).

Picture postcards and photographs which have been retouched to show every element of the composition at maximum intensity are unnatural lies that affect the sensitive eyes of an artist as adversely as disorganized aberrations of musical composition offend the artistic musician's ears. The painter who uses such reference should modify the colors in accordance with a creative color scheme that is visually unified. Some painters affect unity by including some of one hue in the mixture of all the hues used in the composition, i.e., some cadmium yellow medium mixed into the blues of the sky, the greens of the landscape and the reds of the barn could unify an otherwise nondominant hue composition and render it more aesthetically pleasing in the manner that nature would normally bathe such a com-

position with sunlight.

Unusual but equally pleasing effects could be created by the employment of other hues as dominant hue admixtures. As an exercise, find a typically over-intense picture postcard. Re-compose it (in accordance with the Golden Mean) and add a dominant hue to every color that you use for the rendering. Try several paintings of the same subject using a different dominant hue each time. The results will surprise you.

Creative color composition begins with a careful study of nature, but an artist must be more than a camera. What is to be imitated is nature's *manner of working* and that is the essence of the creative act.

Employment of the natural principle of dominance with regard for hue can be extended with regard for value. For example, you could render that same picture postcard with dominantly dark values plus a discordant light value in a small area for a Rembrandt effect or dominantly light or high intermediate values for an Impressionistic effect, etc. For more creative effects you could select one of the following color schemes, *maintaining the principle of dominance as a constant imperative.*

Color Schemes and Harmonic Relationships Based Upon The Color Wheel

Monochromatic—Use but one hue, with variations of value and intensity. Keep one value and one intensity dominant (covering the greatest area).

Harmonic—Use any two hues which are next to each other on the color wheel, but keep one hue dominant in area. Employ variations of value and intensity, but keep one value and one intensity dominant in area.

Analogous—Same as the harmonic color scheme, but use any *three* hues which are next to each other on the color wheel.

Complementary—Use any two hues that are opposite each other on the color wheel, but allow one hue to be dominant in area, along with one value and one intensity.

Split-Complementary—Use as your dominant hue any hue on the color wheel plus the two hues on either side of its complement. Keep one value and one intensity dominant, also.

Analogous-Complementary—This is the most effective color scheme, in my opinion. Use only three hues that are next to each other on the color wheel (but allow one hue to dominate in area) plus the hue that is centrally opposite — green, yellow-green, blue-green plus red-purple, or yellow, yellow-green, yellow-red plus purple-blue, etc.. This color scheme is most effective when some of one hue is present in each of the initial three hues selected, i.e., blue, purple-blue and blue-green (blue appears in all three), etc.

Portraitists who may wonder how they can experiment with creative color schemes when their subject matter is just the model and a "plain background" should reconsider that background; it doesn't have to be so plain. Try the analogous-complementary color scheme for the rendering of that background and you'll come up with something far more interesting than a single hue conception. This color scheme can be used any time you need to render a large area, i.e., a sky, a field of grass, a distant mountain.

The analogous-complementary solution to the rendering of large areas was a favorite of several Impressionists, especially Monet and the Neo-Impressionist, Seurat. If you study some of these paintings you are likely to see they are rendered with small pieces of paint, juxtaposed and not blended, green, blue-green, yellow-green, and red-purple. Such pointillists' paintings depended upon the spectator's eyes to do the blending. The effect is vibrant. Van Gogh even experimented with the implementation of such a variegated color scheme in his rendering of flesh.

Many art students are drawn to the work of the Impressionists and the schools that followed because they rebel against the structure and regimentation of the classical academic approach. What the students fail to realize is that a number of the Impressionist masters were schooled quite thoroughly in classical academic technique.

My effort to perpetuate the method of the classical academy is received by some as an archaic one doomed to create a breed of non-creative artists, involved with the imitation of an ancient craft that

has little place in contemporary society. I disagree. If a musical composer were to create a symphony today in the same manner and skill as Brahms or Mozart, would the piece be any less beautiful? Innovation is not synonymous with quality. Because a *method* has been used before does not mean it cannot be equally effective again. Such a shallow argument, unfortunately has inhibited many students of art, because they have had the cart (creativity) placed before the horse (craft) in their classrooms.

The few directions I have listed show that there are certainly creative directions that an artist can take once he has mastered the craft, without necessarily straying from the communicative idiom. There should be no compunction for an artist to express himself with realistic representation, providing that his motivation is not to imitate. Trying to recreate a photograph is indeed a secondary effort, to go beyond photography in the representation of realistic forms can become first class art. Color harmony is but one of the tools with which you can reach this higher status of internationally communicative art.

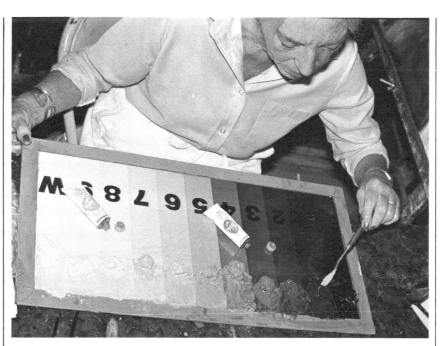

FIGURE 136

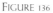
Add sky light to grays that are used for shadow values, sunlight to grays used for illuminated values. The middle value should get both.

FIGURE 136
Flesh row is a mixture of the gray values plus the complexion values. Add the color to its corresponding gray value gradually, until the mixture matches the flesh tone you seek.

THE FRANK COVINO ACADEMY OF ART
TEN INTER-HUE VALUE CHART FOR ADVANCED STUDENTS
(including the Liquitex Modular oil colors)

	Purple Red Purple	Purple- Purple Blue	Blue- Purple Blue	Blue- Blue Green	Green- Blue Green
9	Add White to 8	Add White to 8	Add White to 8	Add White to 8	Add White to 8
8	Add White to 7	Add White to 7	Add White to 7	Add White to 7	Add White to 7
7	½ Light Magenta Plus ½ Permanent Light Violet	Add White to 6	Add White to 6	Add White to 6	Add White to 6
6	Mix 7 with 5	⅔ Light Blue Violet Plus ⅓ Permanent Light Violet	⅔ Light Blue Violet Plus ⅓ Permanent Light Blue	⅔ Bright Aqua Green Plus ⅓ Permanent Light Blue	½ Bright Aqua Green Plus ½ Light Emerald Green
5	½ Medium Magenta Plus ½ Brilliant Purple	Mix 6 with 4	Mix 6 with 4	½ Turquoise Green Plus ½ Brilliant Blue	½ Turquoise Green Plus ½ Brilliant Green
4	Mix 5 with 3	Mix 6 with 3	Mix 6 with 3	Mix 5 with 3	Mix 5 with 3
3	½ Deep Magenta Plus ½ Prism Violet	½ Brilliant Blue Purple Plus ½ Prism Violet	Cerulean Blue Plus Brilliant Blue Purple	Mix 5 with 2	Mix 5 with 2
2	Mix 3 with 1	Mix 3 with 1	Mix 3 with 1	Mix 5 with 1	Mix 5 with 1
1	½ Alizarin Plus ½ Dioxazine Purple	½ Ultramarine Blue Plus ½ Dioxazine Purple	½ Ultramarine Blue Plus ½ Cobalt Blue or Prussian Blue	½ Thalo Blue Plus ½ Thalo Green	½ Thalo Green Plus ½ Viridian

Green-Yellow Green	Yellow-Yellow Green	Yellow-Yellow Red	Red-Yellow Red	Red-Red Purple	
Add White to 8	Add White to 8	Add White to 8	Add White to 8	Add White to 8	9
Add White to 7	⅓ Zinc Yellow Plus ⅔ Brilliant Yellow-Green	Add White to 7	Add White to 7	Add White to 7	8
½ Brilliant Yellow-Green Plus ½ Lt. Emerald Green	Mix 8 with 6	Cadmium Yellow Deep	Add White to 6	½ Light Magenta Plus ½ Medium Portrait Pink	7
Mix 7 with 5	Mix 8 with 5	Mix 7 with 5	Vivid Red Orange or Winsor Orange	Mix 7 with 5	6
Mix 7 with 4	Mix 8 with 4	Mix 7 with 4	Mix 6 with 4	½ Medium Magenta Plus ½ Cadmium Vermilion Red Lt.	5
½ Chromium Oxide Green Plus ½ Emerald Green	½ Raw Sienna Plus ½ Chromium Oxide Green	Mix 7 with 3	Mix 6 with 3	Mix 5 with 3	4
Mix 4 with 2	Mix 4 with 2	½ Raw Sienna Plus ½ Burnt Sienna	½ Burnt Sienna Plus ½ Venetian Red	½ Deep Magenta Plus ½ Acra Red	3
Mix 4 with 1	Mix 4 with 1	Mix 3 with 1	Mix 3 with 1	Mix 3 with 1	2
½ Permanent Sap Green Plus ½ Viridian	½ Permanent Sap Green Plus ½ Raw Umber	½ Raw Umber Plus ½ Burnt Umber	⅔ Burnt Umber Plus ⅓ Alizarin	Acra Violet	1

NOTE: Artistic license has been exercised by the author with slight modifications of the Liquitex oil color map and mixing guide, in conformance with his own observations and pragmatic application of these colors to renderings of natural environments. It is his belief that these are the hues most seen in nature, at grades of lesser intensity. The hue Red-Yellow Red, for example, weakened with corresponding gray values, will produce the most commonly seen Caucasian and Negro flesh tones.

VI | Mixing Color on the Controlled Palette

Before the advent of oil painting, Italians graced the walls and ceilings of the chapels of their patrons with the medium known as fresco. This involved the application of a water based paint into wet freshly applied plaster. The colors had to be pre-mixed, as the plaster dried fast and there was no time for dabbling by trial and error. Painters worked in small sections at a time, often teamed with assistants who had the job of transferring the enlarged sketch or "cartoon" by pouncing after the mixing and application of plaster.

The procedure went something like this: the Master would conceive the original idea and make a small sketch. This sketch was then graphed on parchment to the proportionate scale of the wall or ceiling destined for the final painting. That wall was also graphed on the larger scale and, when the Master was ready to paint, each square of the final graph was plastered individually, usually by an apprentice or assistant to the Master. During this preparation, another assistant would then trace the Master's enlarged sketch with a pouncing tool which punched holes through the parchment directly through the lines of his sketch. Each square of this large graphed and perforated line sketch was then cut out and pressed onto the freshly plastered square on the wall. A black powder, probably charcoal in a cloth bag was then pounced over the sketch and forced through the small holes.

When the square parchment was lifted from the wet plaster, a dotted line charcoal sketch remained in the wet plaster square. The Master had to work fast in order to create a permanent bond between his color and the quick drying plaster. There was no time for trial and error. His palette was "controlled"; the subtle changes of value and intensity were pre-mixed and kept in separate containers. Pouches made from animal organs were usually used for containers, sometimes worn hanging from the artist's belt.

Easel paintings prior to the early Renaissance were usually executed in a form of tempera, also a water based paint, mixed with the yolks of eggs for permanence. Small paintings were done on seasoned wood, usually poplar, after sizing and applying gesso to the panel. Large easel paintings were enlarged onto stretched canvas by graph transfer from small sketches. The first color applied to the gessoed panel was called *imprimatura*. Its hue was complementary to the final predominant hue. If, for example, the painting was of a landscape which had a large area of blue sky, the imprimatura selected was yellow-red.

It was reasoned that color in nature, except for that found in some flowers and the color of the sun itself, was never of maximum intensity. The complementary imprimatura gave a vibratory effect to the superimposed hue and made it less intense. It was also accepted that the halftone areas (those areas that separate the illuminated portions of solid forms from their shadowed planes) looked more natural if they reflected a hue that is complementary to the local color (actual hue) of the form. A green garment, therefore, was often painted or blocked in roughly with red-purple tones: the green values

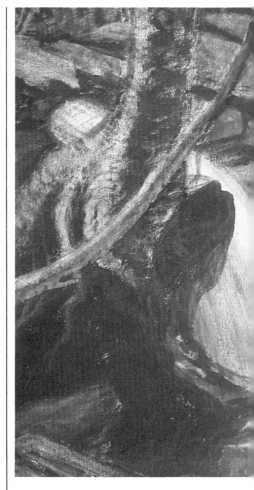

were then superimposed and the red-purple was allowed to show through the green in the halftone sections.

Since flesh was considered predominantly pink (a high value red-yellow-red, for most Latin complexions) the "underpainting," as it came to be known, suggested the use of the complement, a weak blue-green. The term *verdaccio* (greenish-gray) was coined. After experimentation and evaluation it was decided to render flesh areas in weak intensity blue-green values first, then allow some of this under-

Andrew Wyeth, one of the finest classical academic painters of narrative art in this century, often uses this time-consuming egg tempera technique.

When oils were discovered as a medium, the blending of two different values became easy. Oil paint itself is no more than pigment mixed with linseed oil. The pigment was derived from many sources. Different types of soil and clay created good umbers and siennas. The blood of a roach made a rich alizarin, with scrapings from charred animal bones mixed with oil made a great ivory black. With the same volatile component, oils of different hues and values blended readily. Various mediums were tested for blending properties, glaze characteristics, etc., and each Master developed a formula which he often kept secret.

The new medium of oils made the paint most suitable for thin superimposition over imprimaturas. Painters eased into the new process by laying out their verdaccio in tempera and overpainting with oils. Some of the braver ones decided to forget about tempera altogether and use the oil paint exclusively. Problems soon arose. In certain areas cracks developed in the paint surfaces within a few years. Isolating those areas, it was reasoned that some colors had an innate propensity to dry faster than others.

If a quick-drying paint was applied over a color which took longer to dry, cracks and fissures soon appeared on the surface. This was due to the character of the pigment and to the quantity of oil needed to turn it into a paste or "oil paint." White lead, the white that was preferred at that time (similar

tone to show through in those areas where light met dark.

To my knowledge, only one rectangular easel painting by Michelangelo exists today "The Virgin and Child with Saint John and Angels," presently at the National Gallery in London. Fortunately for students of the academic painting process, the painting is incomplete. Two figures are still in *verdaccio,* while the others have been completed in full color.

Tempera painting required a good deal of patience. While some blending is possible by thinning the paint with water, for the most part it is difficult. This means that an edge can only be "lost" by moving from one value to the next in tight steps with separate fine strokes of paint, i.e., to move from shadow value three to halftone value four, stroke values would number three, 3.25, 3.5, 3.75, four, with a few strokes for each value change. It was most practical to have a full range of values premixed in separate containers. Thus began the concept of a *controlled palette.*

127

to flake white or chremnitz) needed very little oil to turn it into a paint. The black made from charred bones required a lot of oil. If the oil used was similar to the fat linseed oil used by manufacturers today, and evidence suggests this to be the case, the oil dried from the top down, leaving a thick film. You can recreate the reaction quite simply by painting a thick swatch of ivory black on a separate piece of canvas. When it becomes dry to the touch, immediately paint over it with a swatch of flake white. Then wait. In less than a year, there will be a network of fine cracks on the surface of the painted area.

Requirements of the craft soon materialized. Rules, structure, a formal approach was devised for the sake of permanence. Schools and academies developed "techniques."

Turpentine was and still is the safest thinner to mix with paint used close to the support, whether that support is canvas or wood. Moreover, careful analysis of the paint ingredients must direct precisely which paints are safest for underpainting and which are more suited for overpainting.

The verdaccio developed from a rough block-in of shadow and halftone values to a full value underpainting. It was reasoned by the early academicians that color, in the representation of three-dimensional forms, was really a secondary consideration as it is but a facade, an embellishment of form. We perceive form because of light and shade. Without light we see nothing. Without shadow we get closer to a two-dimensional representation. The study of values or *chiaroscuro* began when an apprentice first picked up his drawing

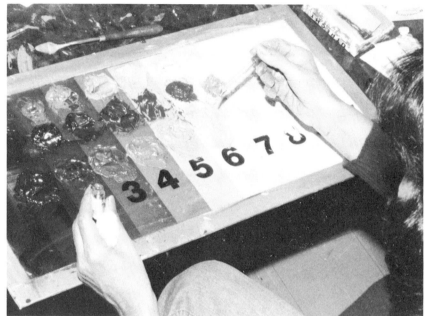

FIGURE 138
Oil of cloves is a blessing for the beginner or for the painter who has no patience for the remixing of dried oil paint.

implement.

Years of study at the various academies often kept the student in a monotone world with the embellishment of color application promised as a reward for mastering chiaroscuro. Cubes and spheres were his first models, illuminated from a variety of angles. Then came plaster casts of body parts, then the whole body plaster casts and finally work from the live model, but still with one color. The color used for the verdaccio was similar to the chromium oxide green we know. It is still the best underpainting color from the standpoint of permanence. An umber-like tone called *bistre* was also popular. The umbers produced today have too much oil in their consistency to be considered safe for underpainting, unless they are mixed by at least fifty percent

with a color of less oil absorption, as shown in the chart on page 86. Only turpentine should be used as a thinning medium.

Raw umber is popular for use as an underpainting color by Frank Reilly-trained illustrators who practice the rub-out approach, but it should be pointed out that these artists are not interested in permanence. Many of them work on the least permanent support; the paper of illustration board. Although the umber rubout approach was recommended by me in my first book as a good one for underpainting, I also advised mixing raw umber equally with lemon or zinc yellow (a color of low oil absorption), and I advised only new students to use linseed oil and oil of cloves to prolong the drying of the paint. I repeat, this is an unprofessional and dangerous practice, with

regards to permanency.

Since the Masters were advising the use of quick-drying paint and an evaporating oil-like turpentine for thinning underpaintings, you can imagine how frustrating it must have been to see the paints dry on their palettes before their underpaintings were completed. Airtight sacks were developed from the organs of animals in which the mixed paints were stored. These sacks were worn about the waist like those of the fresco painters, hanging from a belt and sometimes from a belt drawn across the chest like a bandolier. At the end of each painting session they were topped off with water for airtight assurity.

Other painters preferred to keep their gray-green or verdaccio tones in separate "vessels" on a table next to their easels. Boltraffio mentions ten of these jars, in equidistant gradations from black to white. Lazier students probably narrowed that value range to less, but the Master realized that the more value changes a painter used, the closer he would be to a convincing three-dimensional illusion.

From Boltraffio we learn that the pre-mixed color palette was a natural follow-up to the prepared value palette of the verdaccio painter. Some painters, noting the decreased intensity effect of painting with a thinned complementary color over a dense imprimatura, preferred to decrease the intensity of their final hues by intermixing them with complementary hues. It is certainly possible to make a yellow duller by adding to it a purple-blue, and many painters, particularly the less academic, still paint that way today, but what many do not realize is the complementary hue must first be lightened to the value of the yellow, or the painter will mix instant *mud*.

A "muddy" color occurs when a dark value hue is mixed with another hue of a considerably lighter value, particularly if the hues are opposite on the color wheel. Leonardo, Boltraffio's master, preferred to mix a neutral gray of a corresponding value to a hue to weaken its intensity. With this approach there was no risk of losing the hue and no danger of losing the value. Boltraffio's mention of "10 vessels" of neutral gray placed above the Master's palette is the first mention of such a controlled palette I have been able to uncover in my research of early Master processes. I believe that this method was followed by academic painters for centuries, at least until painters left their studios and went out into the fields to paint. The controlled manner of the Renaissance Masters continued into the Victorian era and was probably practiced by American painters like John Singer Sargent, whose facile handling of a loaded brush suggests a pre-mixed palette. We know that some early American illustrators, such as Maxfield Parrish, used an underpainting, glazed some color and applied thicker tones from a controlled palette. Also, Dean Cornwell, a wizard with controlled values, passed on his method to memorable artist-teachers like the late Frank Reilly. Among the fine artists of this century who have been successful in perpetuating this classical academic approach is the inimitable Salvador Dali, a superb technician.

If every color we see is less than maximum intensity, it would profit us to begin a controlled or prepared palette by mixing equidistant gray values between black and white. As you know, I suggest nine values, where each value represents a *percentage of light.* Black, the absence of light, is zero; and white, 100% light, we'll call ten. Thus value *one* is ten percent light, close to black, while value *nine*, ninety percent light, is close to white.

It's wise to begin with *neutral grays;* that is, they should be neither warm nor cool, for least adulteration of the hues to which they are added. The Grumbacher Co. produces four neutral grays, but they are expensive and, as already stated earlier, their numbers have no relationship to their specific values. If you use these grays, be advised that Grumbacher Gray #1 is really a ninth value; #2 is a seventh value; #3 is a fifth value; and #4 is a second value. Numbers 3 and 4, mixed together in equal amounts, will produce a third value. Number 4 and Ivory Black

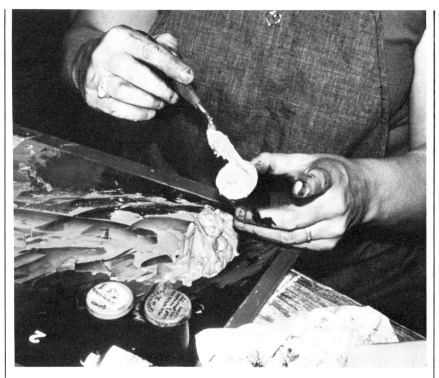

FIGURE 140

35mm film containers are airtight, suitable for paint storage. Grease the inside with olive oil first.

FIGURE 141 →

Glazed blue-jeans look most convincing when they have been underpainted thinly on canvas, as the weave will produce the character of denim.

will give you a value one. Intermixing will produce the missing values.

Some of my students like to conserve time and save money by mixing large amounts of neutral gray values and storing them in airtight containers. As the organs of animals are not that easily procured today, an ideal container is the airtight 35mm film container, available at any good camera store. For storing greater quantities, you can acquire empty paint tubes from some art stores. If your budget allows, you might even consider jelly jars. Anything airtight will work, but I suggest you grease the inside first with olive oil, and fill any space between the paint and the cap with water, which can be poured out at each new painting session.

Mars or ivory black, mixed with a good titanium white will produce cool grays, bluish. These can be neutralized with the addition of raw umber in the low values, raw sienna in the middle values, and yellow ochre in the high values. Before mixing the local colors of the subjects in your painting beneath these neutral grays, you should first condition the grays in accordance with the hue of the *light source*, as follows.

The color of the light source should be present in all the colors used in your painting. By establishing a particular time of day outdoors, or an indoor circumstance such as incandescent light or candlelight, the presence of the light source hue in all the colors you use helps to unify the painting. With the Controlled Color Palette,

the color of the light source is added to a row of neutral grays at the top of the palette. Since all of the colors used on the palette will have their intensities modified by these grays, they will also receive the color of the light in the admixture.

For example, a pair of jeans are purple-blue in hue, but a mixture of white with ultramarine blue would produce too bright a hue. This intensity must be neutralized (made duller) in order to match the true (local) color of the jeans. Painters who are unfamiliar with the Controlled Palette would cut the intensity of the ultramarine by adding a yellow of the same value, what is commonly called *brown*. We reduce the intensity by adding a neutral gray of the same value. If that gray has some lemon or zinc

yellow in it (the approximate color of incandescent light), then the resultant mixture will match the color of the jeans exposed to such lighting. A similar effect can be created by glazing with a thin mixture (mostly medium) of ultramarine over a brown or warm gray underpainting.

If your painting is an indoor scene you need only be concerned with two types of lighting, incandescent and firelight, including candlelight. Forget about fluorescent lighting. Some lighting manufacturers claim they have balanced fluorescent bulbs to simulate daylight, but to my mind their products are still a ways from perfection. So it stands fluorescent is the least flattering of all forms of illumination and should never be used to light up your palette, your painting, your subject or yourself!

Outdoors there are many more considerations. Morning light is quite different from sunset, moonlight has its own variations, overcast days provide lighting decidedly different from sunny days, and when the sun is not clouded over the light from the sky illuminates the shadows.

Study the chart on page 134 for colors of the light at different times of the day and see how the

Artistic representations of colors of the light at different times of the day		
TIME OF DAY	**SUNLIGHT**	**SKYLIGHT**
Dawn (no sun visible) Values 2 to 7		Purple-Purple/Blue (use half Cobalt Violet plus half Ultramarine Blue)
Morning (early sunrise) Values 2 to 8	Lemon Yellow	Purple-Purple Blue
Ten A.M. to One P.M. Values 1 to 9	Cadmium Yellow Light	Blue-Purple/Blue (use half Cerulean plus half Ultramarine Blue)
Two P.M. to Four P.M. Values 1 to 9	Cadmium Yellow Medium	Blue-Purple/Blue
Sunset Values 1 to 8	Cadmium Orange	Purple/Blue (Ultramarine Blue)
Twilight (no sun visible) Values 1 to 7		Purple/Blue
Moonlight (low on the horizon) Values 1 to 6	Moonlight reflected as Blue/Green (use Viridian)	Purple-Purple/Blue
Moonlight (high in the sky) Values 1 to 6	Moonlight reflected as Purple/Blue (use Ultramarine Blue)	Purple/Blue

Add these colors to the grays on your Controlled Palette before using those grays to condition the intensity of your local colors. Add sunlight colors to the high value grays which will be used to paint directly illuminated areas and add skylight colors to the low value grays which will be used for indirectly illuminated shadows.

NOTE: These colors of the light and palette values have been selected to represent the various times of day. They were indicated from my studies of the color of a white card as it appears during those designated periods. There are, of course, variations, i.e., a setting sun can vary between a very weak intensity yellow and a high intensity red-yellow/red, but our intention, in this task of creating a three-dimensional illusion, is to portray the *schemata* with which the majority of our visual audience is familiar. I believe this prescription will answer our needs.

color of sky light is added to the shadow grays, while the color of the sun is added to the grays which will be used for illuminated areas. Once the grays have been conditioned at the top of your palette, you're ready to mix your color values.

Using your color charts, determine the hue required for your painting. New students, working from colored photographs in their early landscape attempts, are encouraged to hold the photographic reference over their charts and identify each of the hues, their respective values and their particular intensites. A hue, value and intensity sketch is made, initial glazes are applied, and then the Controlled Palette is planned. See Figure 145.

Figure 142 shows an interesting color photograph taken in a wooded setting behind our home in Vermont. I liked the photo, but thought I could improve the composition by employing the Golden Mean proportion. Changing the pose and expression of the model to relate it to a personal tragedy, and rearranging the stones and trees to make them look more ominous, I was able to make the statement more allegorical and give more meaning to the painting than there was in the original snapshot. If "a picture is worth a thousand words," then a painting must be worth a book, for a camera can only record what it sees, but a painting can be selective and rearrange natural forms to tell the story beneath the surface.

The photograph is comprised of predominantly warm browns. The yellow-green shirt provides an interesting contrast, but has little

green to relate to in the rest of the composition. I chose to begin with an acrylic underpainting in verdaccio and allow some of this green to remain as part of the final color scheme to effect a harmonious relationship with the model's shirt. Color application began with oil glazes and continued with a Controlled Palette for the opaque applications of oil paint.

It is evident many Master painters of the High Renaissance and their followers employed glazes to begin coloring their underpaintings. An expression from Titian is still used in academic art schools: "...glazes! Forty or fifty, before you begin to apply opaque color." This accounts for the innumerable subtle variations of color present in the best of these

FIGURE 142
Nice photograph by Ed Wyka, but I felt that the model is too centered, the pose it a bit scrunched, and the color of the environment is too monochromatic. With Ed's permission, I would make a few changes, including compositional adjustments to employ the Golden Mean.

FIGURE 143
The Last Fall.

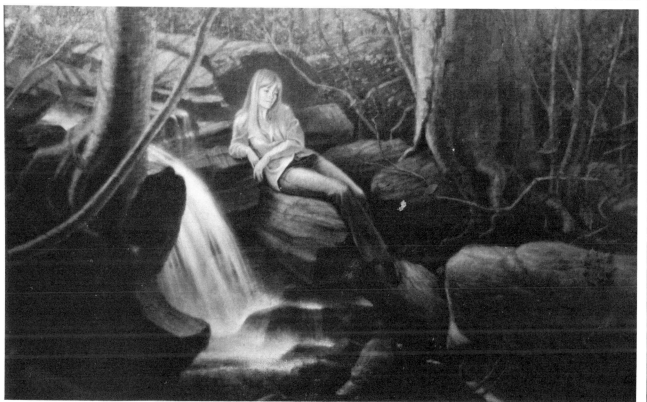

FIGURE 144
A typical hue, value and intensity sketch.

FIGURE 145
Lay out every Controlled Palette with a set of grays at the top which range from the lowest value of your painting to the highest value. (This range will differ in accordance with the light that is represented). Student Thelma Tierney begins her painting with glazes.

works, and it is one of the reasons why they are so difficult to copy with precision.

A glaze is simply a transparent application of color, comprised mostly of *medium*, and that medium should be a formula which includes a varnish. The effect is as though the glazed area has been placed under a piece of colored glass. Glazes may be applied over dried areas of paint or into previous glazes, wet into wet, for a variegated effect. Every Old Master had his own formula for glazing and they usually preferred to keep this a secret between themselves and their students. We know that Venetian turpentine was a popular ingredient; it is thick and viscous and promotes good adhesion. We

know also that linseed oil was heated in the sun to relieve it of its impurities and reduce its propensity to stain colors yellow. Today, linseed oil that has been heated in an oxygen-free environment is called *stand oil*. Both ingredients are available in most art supply stores.

Although damar varnish probably did not exist in the early Renaissance, it has been proven to be the safest of the varnish variations. It is most flexible and the least brittle when dry. It is my preferred varnish ingredient. Only *rectified* pure gum turpentine should be used as a thinning agent.

You might want to experiment with quantities and devise your own "secret" formula. Following is the one I use.

136

The Frank Covino Painting Medium Formula

Five parts damar varnish
Five parts rectified turpentine
Three parts stand oil
One part Venice turpentine

To liquify Venice turpentine which has thickened, cook it in a double boiler, but be sure to remove the cap from the jar or can. It should be a dark brown, but this color will disperse and the resultant hue of your final medium should be a rich golden amber, or clear fifth value yellow. For a while, Venice turpentine was difficult to find, but now the Shiva Company is producing it in convenient 2½ oz. bottles. The medium is used for glazing, but I also mix a few drops into each pile of paint on my Controlled Palette and replenish it every four or five days to keep the paint creamy.

Beginners and students who don't expect to be painting every day should use oil of cloves in place of medium in their paint piles as a drying deterrent, but be advised that this practice will, with time, turn your painting more yellow. Such a golden glow is not always unfavorable. I believe that a similar glow is present in most paintings by Rembrandt, possibly because of his use of unboiled linseed oil. Partially, it is this glow that imparts the unifying effect that is so visually pleasing. I don't think it is advisable to mix oil of cloves into the same paint that includes my medium. Some students have reported problems arising from this practice: the paint on the canvas or panel gets stringy, like mozzarella.

FIGURE 146
Adding oil of cloves to paint in place of medium.

Incidentally, your art store probably won't stock oil of cloves; most of them are not aware of its use by painters. You can find it in your drug store. Unfortunately, it's expensive. When you first mix your paint, put a drop of oil of cloves onto each paint pile with an eye dropper. There is no need to mix it into the paint; it will work itself in. Add a drop to each pile weekly, cover each with a separate square of Saran Wrap, cover the entire palette with another section of Saran Wrap, slip the palette into a plastic garbage bag and seal it, and you should be able to keep the paint on your Controlled Palette wet and usable for weeks. (Many students store their palettes in a freezer with success, but it is not the coldness of the freezer that keeps the paint wet; it is its air-tightness.) As a final word of caution, don't add paint which includes oil of cloves to the medium you use as a glaze. Use fresh paint to tint the medium.

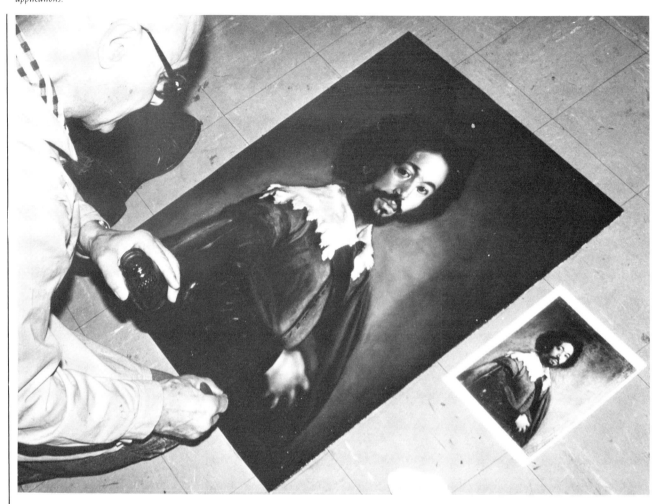

To mix a colored glaze, you may use almost any colored paint, although you should avoid the cadmium types, as they are too opaque. Some colors, like golden ochre and the new brilliant pthalocyanine blues and greens are especially transparent and are ideal for glazing.

Use the umber colors with discretion, as their earth base is more difficult to dissolve completely, and miniscule particles of the pigment might remain floating in your glaze. This can be to your advantage if your glaze is intended to "age" a painted object. To be certain a color completely dissolves in your medium, pour some medium into a glass jar and crush the color on the side of the jar where you can watch the dissolving process.

It is best to apply glazes with your picture lying flat to prevent dripping. Then, let it remain flat for several minutes to ensure adhesion. Think of a colored glaze as you might think of a plate of colored glass. It will tint the area of application with its local coloring and alter the values of the underpainting only slightly, darkening them, of course. Interesting variegated effects may be created by dripping one glaze into another of a different color.

Clear glazes of medium should be applied over any form of underpainting prior to the superimposition of color. Always apply your color into a wet surface for maximum adhesion. Think of the medium as a glue. Color applied onto a dry underpainting might flake and peel off with time. It is advisable to apply a coating of clear medium over the completed dry-to-the-touch painting as a

sealer and gloss equalizer, similar to the damar varnish glaze which should be applied six months to a year later. (A year, if areas of the painting have thickly painted areas, or what the Italians call *impasto;* sooner if the paint has been thinly applied.)

It is conceivable an entire underpainting may be colored with glazes alone if the underpainting has been detailed with precision. This, in fact, was a technique employed by many French Neo-Classicists. Some of them used stand oil as a texture leveling medium over a smooth grisaille or underpainting, and allotting two years for completion. Figure 148 shows how incredibly far student July Chiswell was able to take her excellent copy of a Harnett still life with glazes alone over a verdaccio. Experience has led me to believe some things require opaque applications of paint, particularly if you prefer a painted surface with texture variation. I recommend both methods of color application, coloring as much as you can with glazes first and then applying heavier paint, usually in the lighter value areas. I say "usually," because the old rule of thumb: *paint the dark areas thin and the light areas heavy* does not always apply.

The axiom refers to a technical trick used by the Venetians and borrowed most successfully by Rembrandt and his followers. If the dark areas of a painting are treated *thinly* or spread evenly to eliminate texture, those areas will appear to have depth. Light areas, painted thickly (impasto) will stand out in relief and reflect light from many directions, like the facets of a diamond. Such a treatment will ap-

FIGURE 148
One of the best copies of a Master created in our classroom, this Harnett still life by student Judy Criswell was painted mostly with colored glazes over a minutely detailed verdaccio.

pear to give to a painting inner lumination and create a most convincing three-dimensional illusion. This texture may be created in the underpainting or it may be reserved for subsequent applications of color, a method preferred by Rembrandt. Compared to another painting with a flatter surface, the reflective impasto of the former type will look more alive and have greater aesthetic value because of the tactile variety. The painting may be dominantly thin and smooth, with a small area of heavy paint, or dominantly rough, with small sections of smoothness.

Although the *mostly smooth plus small area of rough* technique is frequently referred to as Rembrandtesque, the method comes from the Venetian Masters who rebelled against the slick, smooth surface paintings of their Italian neighbors, the Masters of the Florentine school, spearheaded by Leonardo da Vinci and Raphael. Remember, photography did not exist in da Vinci's day. The slick photographic surface at that time was considered part of the craft; the absence of brush stroke texture was the signature of the Master Florentine craftsman.

I visualize Titian, supreme Master of the Venetian school, as a more hirsute macho Italian than the well manicured Leonardo who is described by Vasari as tall and handsome, but delicate and impeccably dressed. I imagine Titian bellowing in a deep, raucous voice, "Dominazione, sempre dominazione!" and reasoning that if aesthetics demands a dominant direction, size, shape, value and color in a painting, then it also would insist upon a dominant texture. So the Venetian canvas became more tactile, and the visual experience of confronting a painting became more interesting, and more exciting.

But, rules are sometimes broken, and paradoxically the aesthetics are not harmed by an occasional infringement. They might even be improved, for the aesthetic dictum of dominance may also apply to rules, and if it does, then the natural law must be, "Do it this way most of the time, but don't become chained to an axiom . . ."

In the case of texture on a painting, the variation to the rule would be when an object of rough texture is in the foreground of a painting but is rendered dark in value, a tactile surface is permissible. Thus, the stone in the foreground of *The Last Fall* (Figure 143), is textured both where it is illuminated and where it is in shadow, as is the stone beneath the yellow birch on the left of the

FIGURE 149
Variegated effects can be created by dripping one colored glaze into another.

140

FIGURE 150
Titian, **Man with Red Cap**

perceive things in such order.

A convincing three-dimensional illusion can be painted if you modify the local colors of the objects in an outdoor painting in accordance with this rule. A variable would be when the sun is setting at the distant horizon and the foreground is in shadow. Even then you'd be wise to warm up those foreground shadows and weaken the intensity of the sun to suggest a feeling of depth.

FIGURE 152
The sandpaper worked well on the waterfall also, both for the falling streaks of water and for the spatter of the splash, as the marble dust lent itself once again to the textural effect.

painting. Both areas were textured by mixing marble dust with the gesso-based acrylic verdaccio paint piles. When dry (a matter of minutes with this form of underpainting), I sanded some of the light sections with a rough grade of sandpaper. This lightened the value of the textural peaks and imparted a surface quite like the texture of stone. The colors crushed into my medium for this glaze were raw umber and raw sienna. The warm tone killed most of the green of the verdaccio, but I rubbed off some of the glaze to allow for greenish halftones to suggest moss and reflections. Purposefully, the foreground was kept warmer and darker than the background in compliance with aerial perspective.

The basic academic rule of "aerial perspective" advises artists to keep the foregrounds of their paintings darker and warm and the distant areas lighter in value and cooler, since in normal vision we

FIGURE 153
*Be certain to crush the color on the side of the jar to
ensure total liquification.*

To conform to this curiosity of perception, simply add yellow to all the tones used in your landscape foreground, add red to all the tones of the middle distance, and add blue to all the distant elements. The yellow, red and blue selected for the modification must match the values of the objects that are modified. The intensity of the colors used to create veils of atmosphere must conform also to the basic rule of aerial perspective: close objects appear brighter than distant objects; thus, a good plan would be to modify the foreground colors by adding a small amount of maximum intensity yellow, the middle ground colors by adding a medium intensity red and, to the background tones add a weak intensity blue.

Since I like to begin a painting with glazes before opaque color applications, I usually drench the foreground of my paintings with yellow-influenced glazes, the middle part with red-influenced glazes or scumbles, and the most distant part with blue-influenced scumbles. Remember that yellow includes such variations as raw umber, raw sienna and yellow ochre. Gold

FIGURE 154

Transparent gold ochre glazes were fed to the illuminated sections of the foreground stones repeatedly to make them appear more sunlit. The glaze was wiped off in the halftone areas, to allow the gray-green of the underpainting to show through.

ochre is preferred for sixth value glazes, as it is more transparent than yellow ochre. Red offers variations of alizarin and burnt umber combinations (cadmium red light is too opaque for a glaze). Blue offers all the purple and green variations along with blue. This provides quite a gamut of glaze variations from which you can make your selections.

The quantity of color added to the medium will determine the intensity of the effect. You should realize that glazes over a verdaccio will always be affected by the gray-green of the underpainting. In a landscape, this permeation of col-

ored glazes by the gray-green verdaccio can work to your advantage.

You might have occasion to create a painting when a gray-green underpainting would be of no great advantage. Gray alone might be a better choice for the underpainting. One benefit of such a *grisaille* is that superimposed color can be weakened in intensity simply by allowing the gray of the underpainting to dominate, by keeping the color application thin.

Seascapes are an example of subject matter that might be more convincingly portrayed by beginning with a gray underpainting, but, if much of the area of your

FIGURE 155

FIGURE 156

FIGURE 155, 156
Student Angie Maco completed her entire painting with colored glazes over a gray underpainting.

composition is ocean, you should consider the effect of the three veils of atmosphere over the span of the sea. The water close to the spectator should be rendered more yellow, the middle distance portion more red, and the most distant water quite gray-blue. If the horizon is high, the basic color of the water will be a darker variation of the sky color because of reflection. If the horizon is low, the water may appear even darker, as the wave shadows are likely to be compressed. When using photographic reference for the painting of a seascape, remember the camera is limited in the variations of

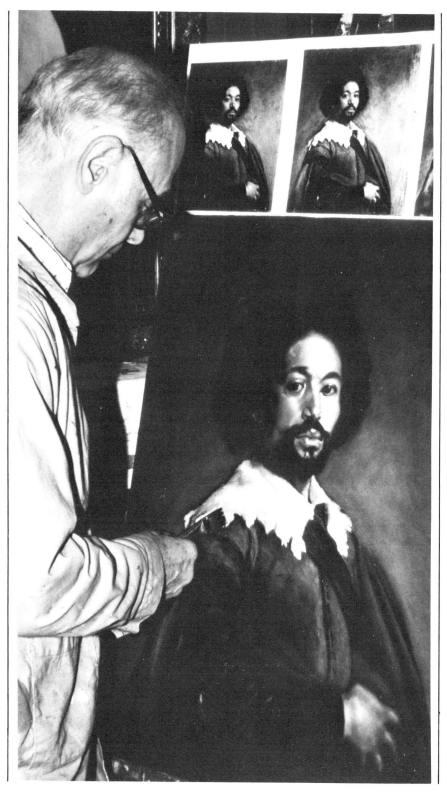

color and value that it can produce. What the camera "sees" is frequently not what we see at the same point of focus.

Water has no color. The color it appears to be must be either the local color of what is beyond it (the ground below) or the local color of what it reflects (the blue of the sky or the color of shoreline trees, etc.), since water is like a mirror. Another consideration would be for the sediment it might carry.

For the painting of water, what appears to be the local color itself might be changed. Close to the spectator, a blue-green might be used (a yellower blue); in the middle distance, purple-blue (a redder blue); and in the greatest distance area, blue, with the intensities of each blue variation adjusted for aerial perspective.

FIGURE 157
Late stage of Art Morello's Velasquez copy.

146

DISTANT FORMS

BLUE

MIDDLE DISTANT FORMS

RED

CLOSE FORMS

YELLOW

FIGURE 158
Human perception seems to be influenced by three veils of atmosphere. Tinting the local colors of your landscape with these veils will create a convincing three dimensional illusion.

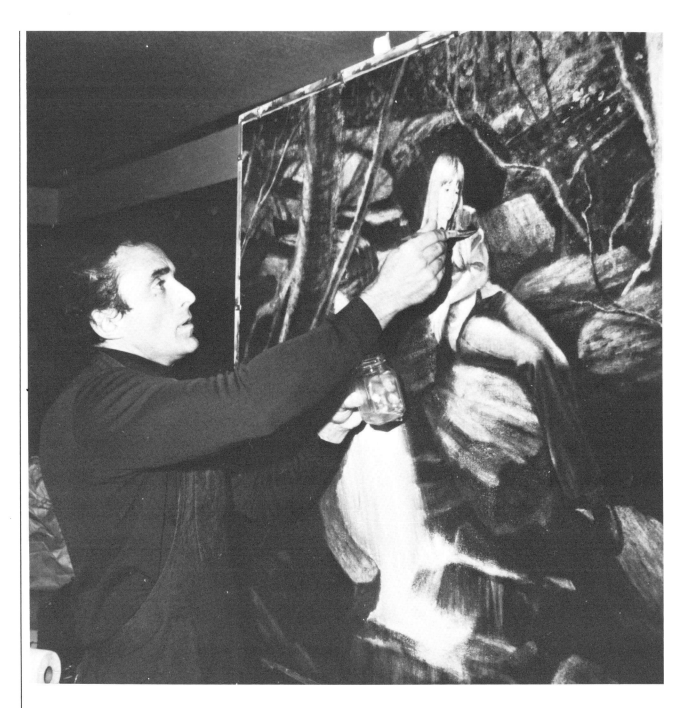

FIGURE 159

Always saturate your underpainting with **medium** *before applying color. Never apply color to a dry underpainting or you may risk it's cracking and peeling later on! I am applying it here over Marge's underpainted blouse to prepare it for color superimposition.*

148

Student Joan Powell began to color her gray underpainting of a seascape with a graphic thought process, a plan which you can see in Figure 160. This was followed by the mixing of three glazes for the weak yellow of the boulders that appear in the water, a raw sienna glaze for the foreground rock (yellow), a burnt umber glaze for the middle distance stones (redder yellow) and a terre verte glaze for the most distant boulders (greener yellow). Raw sienna is a fourth value yellow, close to the predominant value of the foreground stone. It was applied as a glaze once to the entire rock, and twice more to the illuminated portions to bring up their intensity.

Burnt umber is a first value yellow-red. Applied twice to the middle ground stones it made them appear as they might, subjected to the red dust veil of atmosphere. The terre verte plus raw sienna glaze simulated the appearance of a most distant weak intensity yellow stone enveloped in a blue veil of atmosphere.

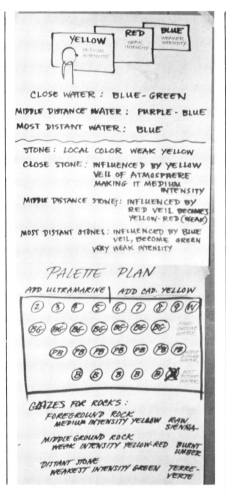

FIGURE 160
Student Joan Powell carefully plans her color application.

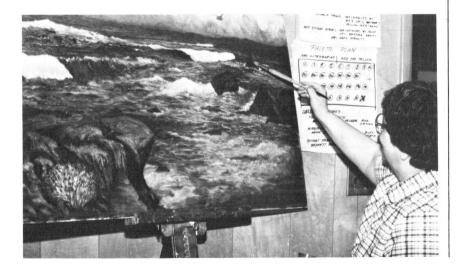

FIGURE 161
Joan's first glazes tinted her boulders.

Joan's plan for the opaque color applications took into consideration water values should be darkest close to the spectator (at this high horizon point of view) and get progressively lighter and grayer as they recede. She also noted that the water closest to the spectator should be rendered brightest (less gray), while the distant part of the ocean should be weakened in intensity by the addition of more gray. These notes were translated into the controlled color palette. The grays at the top of the palette have been modified by the addition of ultramarine blue in the low values (color of the sky) and cadmium yellow light (sunlight) in the high values. These grays were used to condition the hues beneath them for intensity variations.

All values were premixed before paint application. Thus, her painting took on a greater three-dimensional illusion than the original photographic reference, which illustrated the entire ocean section as a blue of equal intensity and value structure. Note the compositional changes the artist incorporated in her painting.

There is no doubt artists can go beyond the photographer in producing a three-dimensional illusion, though they may use the photographer's primary tool to supplement the tools of our craft. We can examine the phenomenon of perception and reproduce its effect upon forms within the visual perimeter, and, as painters, we can create a work of lasting value. This can not be said of photography. Consider this quote from the editor of Popular Photography in

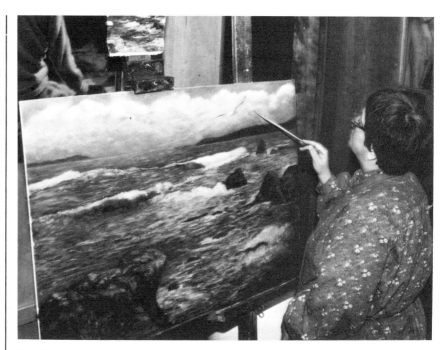

FIGURE 162
Joan's completed seascape showed greater depth than the photographic reference, which she altered enough to call the work her own.

the February 1976 issue:

"Fifty years from now, most of the color we take today won't exist. Molecule by molecule, our color photographs are flying apart, the images changing color and fading, victims of the Second Law of Thermodynamics which states that within any closed system over a period of time, order tends to disintegrate into increasing entropy and ultimate chaos. The rate of change for color transparencies, negatives and prints tends to be considerably faster than what we experience with most black-and-white images. It certainly falls short of anything one might reasonably describe as "archival" in terms of lasting a

hundred or a thousand years, unless stored under conditions which are not widely understood even among many museums and professional photographers today."

We have learned much from Old Masters with regard to the longevity of paintings. Their errors during the experimental period are our examples centuries later. We have learned about the deleterious effects of time and poor craftsmanship, and we have invented materials that are superior to those used by our teachers. Following the procedures described in this book, you can expect your work to last for centuries.

All of this, of course, presupposes we create art worthy of saving for future generations to enjoy.

VII | Concluding Remarks

Earlier I mentioned some artists rebel against the notion that there can be any scientific basis for art. In recent years the objectors have been advancing the argument an artist's best creative effort springs from the anti-structure segment of the mind. The split brain concept is one that was seeded in the experiments of Roger Sperry at the California Institute of Technology three decades ago and culminated for artists in the recent Tarcher publication by Betty Edwards, *Drawing on the Right Side of the Brain*.

Basically, the theory defines the function of the two separate hemispheres of the brain and their relationship to analytic (left mode) and intuitive (right mode) forms of creativity. Each half of the brain processes stimuli in a totally different way. The left side analyzes, intellectualizes, rationalizes, while the right hemisphere responds intuitively and imaginatively.

Since our society places so many demands upon the structured left side, it becomes overworked, while the spatial, artistic right hemisphere seemingly lies dormant, doomed to a role of relative insignificance. Art, producing nothing of absolute necessity, is rejected early in life by many parents who prefer to steer their children toward more functional and lucrative occupations.

Asked to draw, few people are capable of representing the human form with anything more than a childlike symbol. Inherited symbols, or *schemata*, are frequently convenient substitutions for perception of factual data, the stick figure representing the human body; the circle for a head, etc. Children are quick to attach themselves to schemata, as they function on a mechanical level of awareness, with active interest only in things that satisfy their basic needs. Thus, they accept the stick figure as a quite thorough description of a person, quick and convincing enough to allow them to get on to more interesting things like playing in the schoolyard. A surprising number of adults carry such basic symbols of the human form all through their lives, marveling at artists for the "magical" power they seem to have.

The basic difference between artists and non-artists is that the former are sensitive and more perceptive. Non-artists go through life looking but not really seeing. Probably many in the same group listen without hearing, sniff without smelling, taste without savoring and touch without feeling. Such insensitivity may not always be by choice. Early direction has taken its toll.

Can sensitivity be taught? Yes. It is the obligation of the teacher to motivate sensitive response by first

convincing their students that such activity is as worthwhile as mathematics or grammar. They must prove each individual is capable of sensitive response by training him to respond to his aesthetic senses. The best art training includes mastery of craft. This book is a manual for accomplishment in the craft of painting.

Many potential students poke their heads into our classroom and turn quickly away when they see the quality of my students' efforts. Perhaps, they think, "I could never do that!" When I have the opportunity to to talk to them, I outline the progression of our course, and place emphasis upon our approach to painting in the classical manner.

Most people feel intimidated because they can't draw. When they see a new student using the graph approach, their eyes open. "Wait a minute. That doesn't look hard. I think I can do that..." The graph symbolizes a form of cheating...an easy out...and that attracts the practical side of their brain. Any expression that doesn't challenge the imagination is a welcome activity for most non-artists. The graph proves that drawing with accuracy can be a simple form of measure. Measure deals with degrees (how far away from absolute vertical is the slant of that head), and degrees are within the secure domain of the left side of the brain.

Our timid classroom visitors are next given a glimpse into the theory of dark and light, supported by our Controlled Palette, I try to convince them that this next step, chiaroscuro, can also be approached with measure, in the manner described in this book. Another problem of logic and mathematics, with little demand placed upon the dormant imaginations.

Of course, color also can be measured using the Munsell standard of hue, value and intensity. The visitors are soon aware our approach to art only requires basic intellect and a capacity for measuring. They know almost everyone can master such straight-forward procedures.

My students soon realize the elements of painting which can be measured are elements of the craft. Beyond the craft, though, there is art, and art requires imagination. Imagination is a right brain hemisphere activity. In order to exercise it you must turn off the activities of the left side.

This can be accomplished in two ways. You can *bore it*, by mastering all the elements of the craft. That takes lots of practice. "You must paint one hundred heads," I like to tell my students, "before you can call yourself a portrait painter!" When the left side of the brain is bored, it will allow the right side to be more active. You can also *confuse it* by assigning to it tasks with which it is not familiar, like painting from a photo with your canvas and the photograph upside down; or using a rag instead of a brush; or painting negative space, the space that surrounds the form instead of the form; or referring to a scene in a photo but rendering it at a different time of day, or in a different value key.

The significant artistic expression is one created by both sides of the brain, and therein lies the object of this book. I can teach you the craft. I have shown you some of the *science* behind the art in an effort to tease and exercise the left

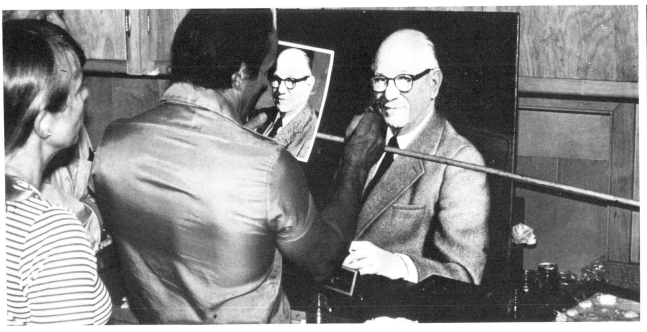

FIGURE 163
The author begins flesh tone application before class of students at his Academy of Art.

FIGURE 164
The finger is a great tool for blending.

FIGURE 165
Applying the glaze to the ash tray.

FIGURE 166
Keep a pin around for picking off stray hairs.

side of your brain. I have tried to convince you that where the craft stops, art begins. Use your imagination, yes, but first train yourself to *see*.

It is hoped these pages will define for you the craft of art and inspire you to practice it and more fully appreciate its significance. My first intention in compiling this manual was to kindle the spark of creativity that resides in all of us, and direct the flame toward significant achievement in communicative painting.

This book is also an expression of my own creative efforts. The significance of the latter intention is dependent upon the success of the first, for an artist is known for what he has created. Our intelligence, the essence of our being, can only survive us in objects we have created, or in persons we have touched and have moved. If the approach shown in this book is meaningful to you my work will be well rewarded.

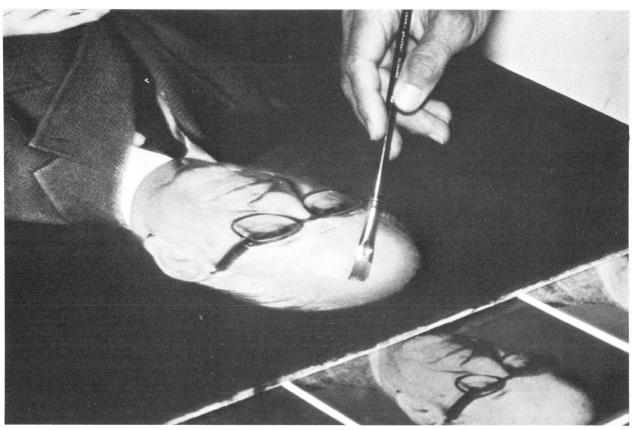

FIGURE 167
To avoid dripping of the glaze, I continued paint application with the painting flat, for the class's observation.

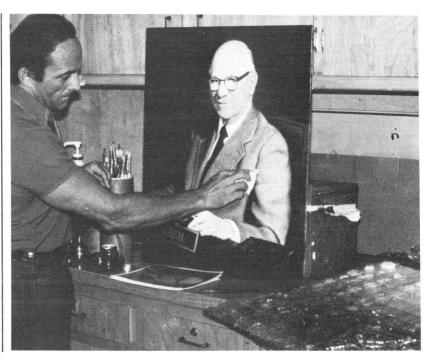

FIGURE 168
After glazing the verdaccio rendering of the jacket with raw umber, I rubbed off the glaze in the highlighted areas.

155

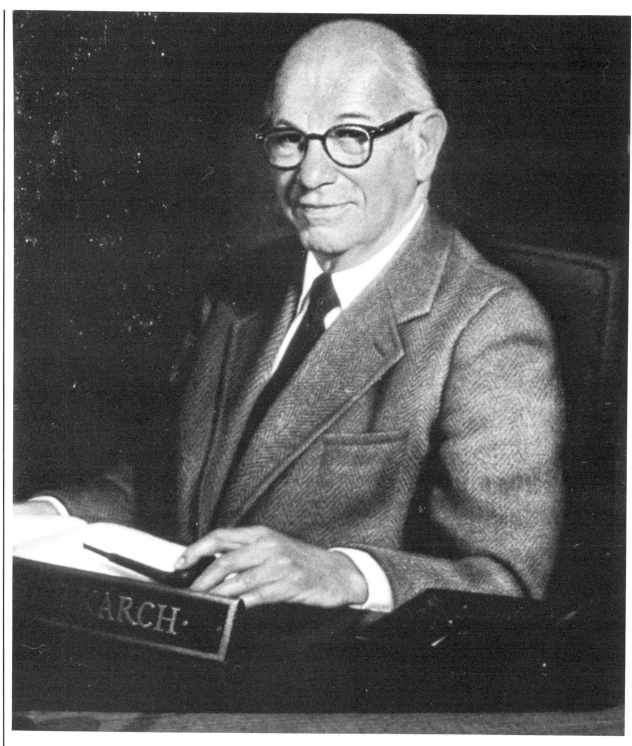

FIGURE 169
Mr. Karch, a moment after my last stroke.

Cassette Critique Service

For your information, I offer a cassette critique service formulated to communicate with distant readers. With a cassette recording, I will analyze your painting and offer options for improvement. It has proven to be an excellent manner of individualized direction and cooperative creativity for anyone with an affinity for the classical academic approach. Should this form of instruction interest you, mail an inquiry to Frank Covino, Village of Sugarbush, North Waitsfield, Vermont 05673, and you'll receive directions for forwarding your work.

"Those who become enamoured of the practice of art, without having previously applied to the diligent study of the scientific part of it, may be compared to mariners, who put to sea in a ship without rudder or compass, and therefore cannot be certain of arriving at the wished-for port. Practice must always be founded on good theory ..."

Leonardo daVinci

Other fine art books published by North Light

American Realist by Stevan Dohanos
An Approach to Figure Painting for the Beginner by
 Howard Forsberg
The Artist and the Camera by Albert Michini
The Artist and the Real World by Frederic Whitaker
A Basic Course in Design by Ray Prohaska
Controlled Watercolor Painting by Leo Stoutsenberger
Croney on Watercolor by Claude Croney
A Direct Approach to Painting by Alfred
 Chadbourn, N.A.
Drawing and Painting Animals by Fritz Henning
Drawing and Painting Buildings by Reggie Stanton
The Eye of the Artist by Jack Clifton
F.R. Gruger and His Circle by Bennard B. Perlman
The Immortal Eight by Bennard B. Perlman
A Judgement of Art by Frederic Taubes
The Magic Pen of J.C. Coll by Walt Reed
The Many Ways of Water and Color by Leonard
 Brooks
The Mastery of Alla Prima Painting by Frederic
 Taubes
North Light Collection
North Light Collection 2
On Drawing and Painting by Paul Landry
Opaque Watercolor by Wallace Turner
Painting Flowers with Watercolor by Ethel
 Todd George
Painting Indoors by Charles Sovek
Painting Nature by Franklin Jones
The Student's Guide to Painting by Jack Faragasso
Variations in Watercolor by Naomi Brotherton and
 Lois Marshall
Watercolor: The Creative Experience by Barbara Nechis
Watercolor Workbook by Bud Biggs and Lois
 Marshall, A.W.S.
When You Paint by Ward Brackett

Other books by Frank Covino:

The Fine Art of Portraiture (1970)
Discover Acrylics with Frank Covino (1974)

Skiing Made Easy (1971)
Snowballing — Diary of a Ski Instructor (1975)
Skier's Digest II (1976)